IMAGES
of America

SAN FERNANDO
VALLEY

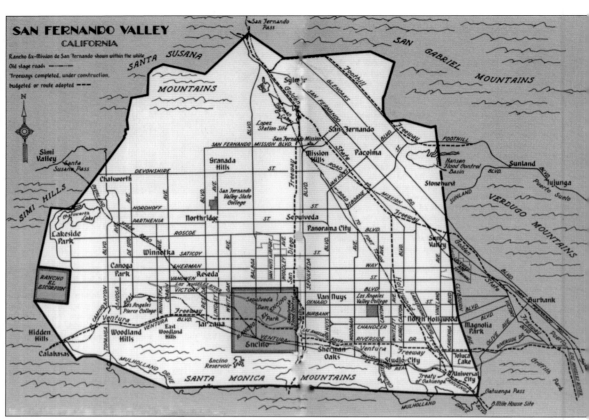

SAN FERNANDO VALLEY HISTORICAL MAP, 1967. The borders of the historical San Fernando Valley are as follows: Mulholland Drive to the south; Calabasas, Hidden Hills, Simi Hills, and the Santa Susana Pass to the west; Newhall Pass (San Fernando Pass), Sylmar, Pacoima Dam, and Sunland to the north; and Burbank and Glendale to the east.

ON THE COVER: This photograph shows a stunning view of Chatsworth that overlooks the southeast of the Iverson Ranch in 1920. Below the hill are now Farralone Avenue and the Union Pacific Railway, which runs through the Santa Susana Pass Tunnel to the west. The rural San Fernando Valley lasted well into the 21st century. (Photograph courtesy of Bison Archives.)

IMAGES
of America

SAN FERNANDO
VALLEY

Marc Wanamaker

ARCADIA
PUBLISHING

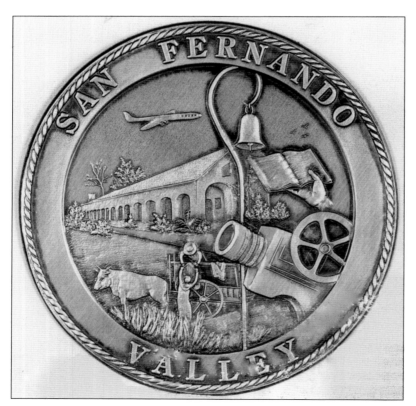

SAN FERNANDO VALLEY SEAL. Designed by John D. McIntyre with original art by Sharon Ader and M.H. Cunnington, the seal depicts the Mission San Fernando, the El Camino Real Bell, and the home of aviation and film industries.

CONTENTS

ACKNOWLEDGMENTS

The preparation for such a project as this took many years. It took years of collecting books, newspaper and magazine clippings, photographs, documents, original memorabilia, and research materials from the collection of Dorothy Denny, publisher and editor of *San Fernando Valley Magazine*. The interviews collected over the years and the information incorporated in this book come from people who have lived and worked in the San Fernando Valley for the past 65 years: Catherine Mulholland (William Mulholland's daughter), the Iverson family (Iverson Movie Ranch), Jack Warner Jr. (son of Jack Warner Sr.), Dr. William Wanamaker (father of Marc Wanamaker who purchased a G.I. Bill tract home in North Hollywood in 1946), Manning Post (owner of Europa Motors), Albert Dorskind (vice president of development for MCA/Universal Studios), Ralph Morgulus (owner of Balboa Pharmacy and camera store), Dick Mason (creator of the Warner Bros. Studio Tour), Yakima Canutt (famed movie stuntman and longtime resident of the Valley), David Smith (head of the Walt Disney Studio Archives), Robert S. Birchard (film historian), and Nancy Ince Probert.

All images in this book are from Bison Archives, unless otherwise noted.

INTRODUCTION

This volume contains a highly compressed history of the San Fernando Valley. It highlights the important facts, focusing on the development of the Valley, the people who pioneered its development, and the landmarks that once existed and still exist today.

The San Fernando Valley is famous for its distinctive way of life. For the past 65 years, its residents have enjoyed the sunny weather and outdoors, from their patios, swimming pools, and gardens, all year round. With the building of the Los Angeles Aqueduct in 1913, the Valley converted its huge dry farms, which relied on wells and river water, to irrigated farms of prosperity. This agricultural wealth set the stage for an extraordinary population growth.

Over the many years, major housing developments, churches, schools, businesses, industries, and individual cities developed to accommodate the increasing influx of new residents. During the 1950s and 1960s, it was popular to build homes on the hillside. It was also popular for tract home construction on the floor of the Valley. Since the 1960s, some of the Valley industries have included the following: Rocketdyne, Atomics International, Lockheed Missile and Space Division, RCA, Chevrolet, Radiophone, Litton Industries, Bendix, Borg-Warner, Carnation Laboratories, and Anheuser-Busch.

The Valley's multiple cities have changed their boundaries constantly, and throughout its history some communities disappeared while others were born. The Valley's original communities had different names. For example, Marion became Encino, and Studio City was originally a part of North Hollywood. As of 2005, the San Fernando Valley was composed of communities that blended their boundaries together. The north Valley consisted of Porter Ranch, Granada Hills and Knollwood, Mission Hills, Sylmar, San Fernando, North Hills, Panorama City, Arleta, and Pacoima; the east Valley consisted of Shadow Hills, Lake View Terrace, Sun Valley and Roscoe, Sunland, Tujunga, and Burbank; the south Valley consisted of Universal City, Studio City, North Hollywood, Toluca Lake, Valley Village, Sherman Oaks, Encino, and Tarzana; the west Valley consisted of Woodland Hills, Topanga Canyon, Calabasas, Hidden Hills, West Hills, Chatsworth, Warner Center, and Canoga Park; and the Central Valley consisted of Lake Balboa, Winnetka, Reseda, Van Nuys, Northridge, and Valley Glen.

Since 1909, the Valley has had a rich history of the motion pictures industry. Countless films and television shows were and are shot around the Valley, in close proximity to the Hollywood studios. In that same year, the early movie industry was the first to pay fees to preservationist Charles Lummis, whose organization's funds restored the Spanish Missions of California.

During the early days of filmmaking, Cecil B. DeMille, a famous American film director, almost destroyed an important artifact of Los Angeles history on his movie set. DeMille filmed one of his first motion pictures on the old Providencia Ranch, which later became the first Universal Studios. While his production men were cleaning out an old adobe hut and burning its trash nearby, DeMille noticed a parchment in the fire. He quickly pulled the paper out of the fire before it was badly damaged. DeMille was astonished; the parchment was one of the copies of an early

Los Angeles Census. He later gave it to the Southwest Museum. The museum, in turn, published copies of the invaluable census.

The author of this book, Marc Wanamaker, grew up in Los Angeles. Wanamaker frequently visited the Valley for most of his life. Having lived in North Hollywood since he was a baby, Wanamaker frequented the Valley to shop, relax, and visit friends and family. The author also attended California State University, Northridge, which was originally called "Valley State." Wanamaker worked at Universal Studios in the 1980s for over seven years, and he continues to consult with Disney Studios, NBC Studios, Warner Bros. Studios, CBS Studio Center, and various chambers of commerce from the Valley.

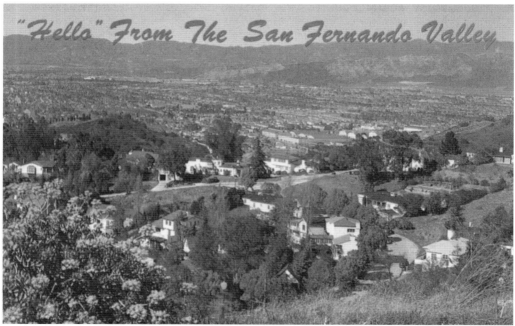

"HELLO" FROM THE SAN FERNANDO VALLEY, 1946. This color postcard from the Union Pacific Railroad was a tourist souvenir. The caption on the reverse said, "this modern residential area surrounded by rolling hills is affectionately known as the 'Bedroom' of Los Angeles." The Warner Bros. Studios are located at the lower foothills of Burbank.

One

EARLY SUBDIVISION
OF THE RANCHOS

The area covering the San Fernando Valley was originally called "Gabrielino," and its name was derived from the Spanish. Gaspar de Portola and Father Juan Crespi acquired Indian lands during the Spanish conquest. On August 5, 1769, Father Crespi named the area Santa Catalina de Bononia de los Encinos. Following the *Portolá* expedition in 1771 and 1772, Father Junipero Serra used the Valley as a route to establish missions in San Luis Obispo and San Gabriel. In 1797, the Spanish fathers of the missions sought a midpoint between the San Buenaventura Mission in Ventura and the mission in San Gabriel, and they found such a site on the rancho of Francisco Reyes. Reyes was the alcalde (mayor) of the *pueblo* of Los Angeles from 1793 to 1795. During that time, Reyes sought a grant from the Spanish crown for land in the San Fernando Valley. Spanish grants were determined by the King of Spain or by Spanish governors. In 1795, the Spanish crown granted limited rights to three distinct portions of the Valley. When the mission fathers inquired about building their new mission on the Reyes property, Reyes provided them with land. The San Fernando Mission was established on September 8, 1797, and by 1813, the Spanish crown gave up its support of the mission system in California. In 1821, much of the church properties became secularized, which led to the demise of the mission system and mission properties.

One of the early governors of California, Juan B. Alvarado, fought a battle with Manuel Micheltorena on the Los Angeles River near Encino. Micheltorena was a new claimant to governorship, and from this engagement came a treaty at Campo San Fernando. On February 22, 1845, Alvarado's friend Pio Pico declared himself the governor of California. Three years later, the San Fernando Valley became US territory. Commander John C. Fremont signed the cease-fire treaty between the Americans and the Mexican California authorities at the Campo de Cahuenga on January 13, 1847. The American period began with the annexation of former Mexican lands.

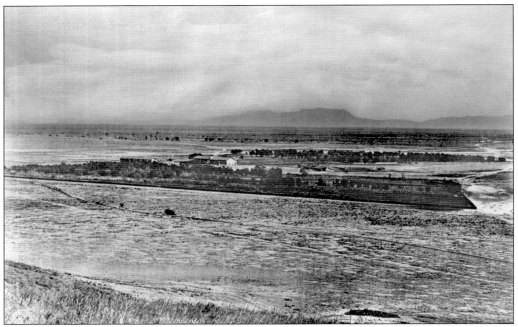

SAN FERNANDO MISSION, REY DE ESPANA RANCHO, 1875. Southeast of the Hollywood Hills is the Cahuenga Pass, which is located at the lower portion of the hills. In 1799, the first mission church was built in the foothills that overlooked most of the San Fernando Valley. After the secularization of the mission system, the San Fernando Mission's rancho lands were given to overseers. At the time this photograph was taken, time and negligence had taken their toll. By 1880, the mission was considered a ruin.

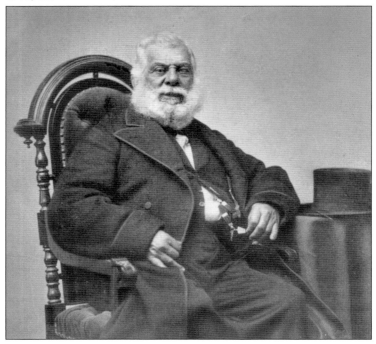

DON PIO PICO, 1846. Pio Pico was the last governor of California during the Mexican period from 1836 to 1846. By the 1850s, Pico was one of the largest landowners in Southern California, and he owned much of the San Fernando Valley. Pico served twice as governor of Alta California, first serving in 1832 and later from 1845 to 1846. Pico built his home on the Rancho Paso de Bartolo Viejo lands, which is now Whittier. He named it "El Ranchito" and built his mansion there.

DON ANDRES PICO, 1847. Andres Pico was the younger brother of Pio Pico. In 1845, Andres and Juan Manso were granted by Gov. Pio Pico a nine-year lease for the San Fernando Mission lands, and in 1853, they acquired half interest on them. Andres ranched cattle and made the mission complex his rancho headquarters. He named his residence the Pico Adobe. In 1847, Andres became governor of the Mexican Alta California. At this time, Andres signed the Treaty of Cahuenga with the American commander Lt. Col. John C. Fremont. This treaty ended the Mexican-American War in California.

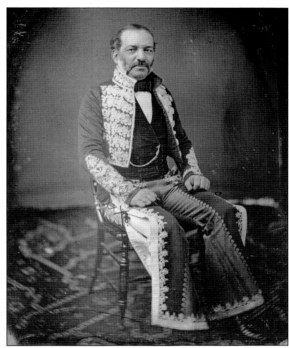

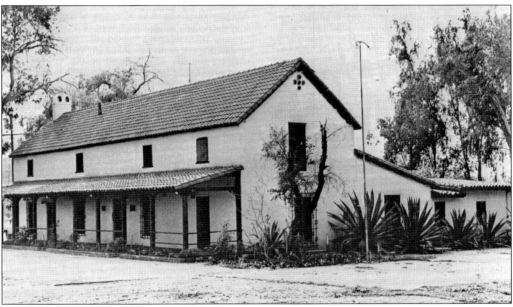

ANDRES PICO ADOBE, 1932. This photograph shows the former home of Eulogio de Celis. In 1846, Celis was granted the Rancho Ex-Mission lands by Gov. Pio Pico. Andres Pico acquired the Celis ranch in 1853 and then moved into the larger San Fernando Mission's monastery house nearby. In 1874, his son Romulo and his wife Catarina moved into the adobe. The Pico Adobe is located at 10940 Sepulveda Boulevard, which is now Mission Hills. In September 1962, the Cultural Heritage Board of Los Angeles declared the Andres-Pico Adobe a historic state landmark, labeling it No. 362.

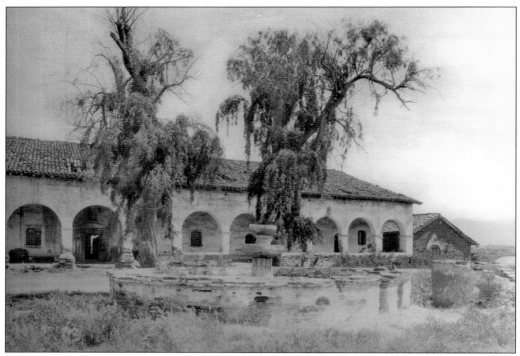

MISSION SAN FERNANDO REY DE ESPAÑA, 1882. Named after the king of Spain, St. Ferdinand, the San Fernando Mission was founded by Fr. Fermin Lasuen on September 8, 1797, as the 17th mission in California. The original church building was constructed in 1799, but it was replaced in 1800. In 1806, a third church was completed. However, it was damaged in the earthquake of 1812. The fountain seen in the foreground, with the Convento (the elongated building) in the background, is now located on San Fernando Mission Boulevard in Mission Hills.

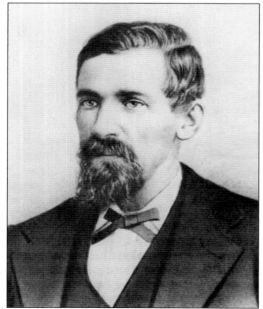

MIGUEL DE LEONIS, 1861. Miguel de Leonis, who was known as "El Basque Grande" or "the King of Calabasas," married Espiritu, an Indian woman of the Cahuilla tribe. The Cahuilla tribe were the original grantees of Rancho Escorpion. When Espiritu's brothers Manuel and Odeon died, her husband became the owner of the rancho. On August 6, 1962, the Leonis Adobe Museum was designated a historic state landmark, labeled as No. 1. It is located at 23537 Calabasas Road in Calabasas.

Two

SAN FERNANDO VALLEY DEVELOPMENT

The development of the San Fernando Valley began with the railroad connection to Los Angeles in 1874. George Porter and Charles Maclay owned the northern half of the Valley, and they established the town of San Fernando on September 15, 1874. In early 1888, the Lankershim Ranch Land and Water Company bought 12,000 acres from the Los Angeles Farm and Milling Association, with the intent to subdivide the land. George K. Porter, through his Porter Land and Water Company, began to develop a tract that was bounded to the north by San Fernando Township. The tract was bounded to the west by what is now Balboa Boulevard, to the east by Pacoima Creek, and to the south by what is today Roscoe Boulevard. At this time, the San Fernando Valley Improvement Company recorded its map for Chatsworth Park. From 1888 to 1898, the growth continued with several new towns created by developers. These included the towns of Van Nuys, Marian (Reseda), and Owens Mouth (Canoga Park). In November 1913, the opening of the Los Angeles Aqueduct made the growth of the Valley possible. The water belonged to the city, and access to the water was gained by the annexation of the City of Los Angeles. In 1915, a large part of the Valley officially became a part of Los Angeles. Another major development was the completion of the railroad tunnels of the Santa Susana Mountains that was constructed from 1898 to 1904. In 1908, the Southern Pacific laid tracks to Zelzah, or what is now Northridge. Another major development in transportation was between 1911 and 1913, when the Pacific Electric construction of the Red Car trolley line through the Cahuenga Pass was completed. Aviation came to the Valley in 1928 with the Los Angeles Metropolitan Airport (Van Nuys Airport). In 1930, the United Airport at Burbank opened. The 1950s brought the era of the freeways. Opened in 1940, the first section was California State Route 170, which was part of US Route 101 and connected the Hollywood area with the east Valley via the Cahuenga Pass. Another section that extended to Barham Boulevard was not completed until 1949. Other sections of the Valley freeway system opened between 1957 and 1968.

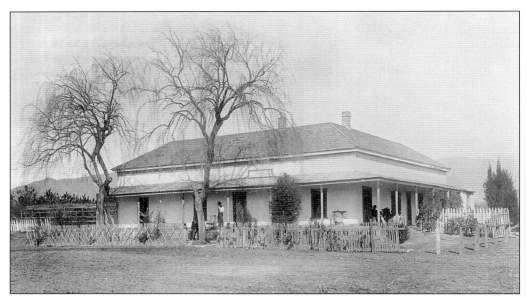

LOPEZ STATION, 1885. Originally a stage depot, Geronimo and Catalina Lopez built a large adobe house on this site and named it Lopez Station. The station continued as a stage and wagon depot. A post office was established there and served the Valley for many years. With the coming of the railroad in 1904, the importance of Lopez Station diminished. The site was a northwest Valley landmark near the San Fernando Mission for another eight years, but in 1912, the building was torn down for a water reservoir.

US HIGHWAY 101, 1913. In its earlier days, the state highway was known as Ventura Road. In more modern times, it is known as Ventura Boulevard. The state highway was the link between Los Angeles and Ventura, and it was also the coastal route leading to Santa Barbara. For a long time, before the road was absorbed into developing communities, it was considered a scenic route to many ranches in the Valley.

PORTRAIT OF BENJAMIN F. PORTER, 1879. Benjamin became partners with his cousin George K. Porter and Charles Maclay when he purchased a partial interest in the land his cousin had originally bought in 1874. That land consisted mostly of the north Valley, which includes the present-day Porter Ranch. Benjamin eventually sold a large portion of his land to the San Fernando Valley Improvement Company in 1888, which established the community of Chatsworth Park. The Benjamin Porter land is today the Porter Ranch and Chatsworth area.

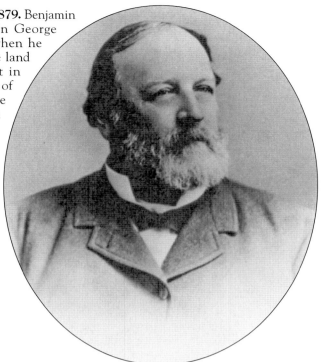

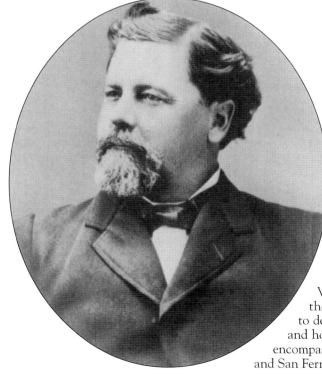

GEORGE K. PORTER, 1874. This portrait shows George K. Porter, who was a state senator. Porter and Charles Maclay purchased the northern section of the San Fernando Valley in 1874. Porter soon established the Porter Land and Water Company to develop his land for wheat production and housing subdivisions. The Porter land encompassed the area where the Lopez Station and San Fernando Mission stood.

15

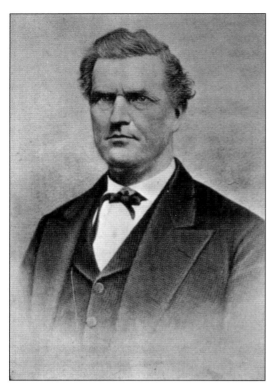

CHARLES MACLAY, 1875. Former state senator Charles Maclay established the community of San Fernando in 1874 on a portion of land he purchased from Eulogio de Celis and his family. Maclay built a two-story home for his family at the corner of Celis and Workman Streets. With the arrival of the railroad and clever planning by Maclay, his efforts ensured long-term growth for this northwest corner Valley community.

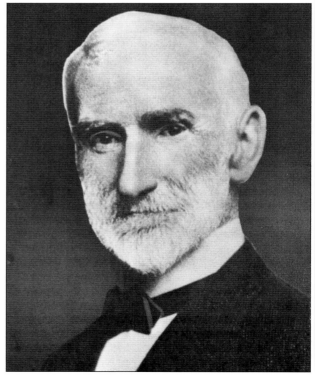

ISAAC NEWTON VAN NUYS, 1912. Van Nuys formed a partnership with Isaac Lankershim in 1869, and he bought in with Lankershim's corporation, the San Fernando Homestead Association. Later in 1874, the partners formed the Los Angeles Farm and Milling Company with other stockholders and turned the southern half of the Valley into an extensive wheat ranch and flour milling operation. By 1888, a record 510,000 bushels of wheat were produced and milled in the Valley.

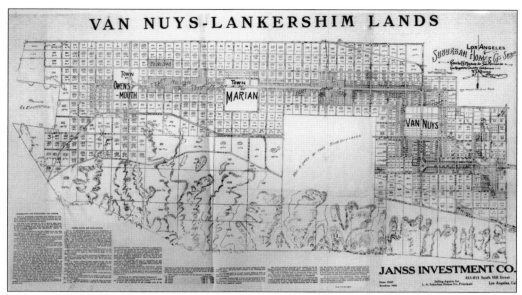

VAN NUYS–LANKERSHIM LAND MAP, 1910. The image above shows the Janss Investment Company development map and the subdivision of the Van Nuys–Lankershim properties. The development company was named the Los Angeles Suburban Homes Company Subdivision of the Ex-Mission de San Fernando of Los Angeles County. It was the Janss Investment Company that developed former rancho land that is now Westwood Hills in West Los Angeles.

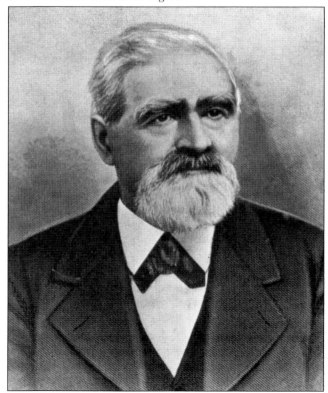

ISAAC LANKERSHIM, 1869. When Isaac Lankershim arrived in Los Angeles from San Francisco in 1869, he purchased a part of the Andres Pico title to the Ex-Mission Rancho San Fernando land. In partnership with his son John B. Lankershim and his son-in-law Isaac Newton Van Nuys, he formed the San Fernando Farm Homestead Association and purchased much of the eastern portion of the San Fernando Valley.

17

JOHN B. LANKERSHIM RANCH HOLDINGS, 1912. This photograph shows a southern view of the Lankershim Boulevard Bridge over the Los Angeles River. During this time, several ranches were located south of the Los Angeles River and east of Lankershim Boulevard. In 1914, Universal Studios purchased these ranches, which included the Taylor, Boag, Davis, and Hershey ranches. The ranches were once part of the overarching Clyman Ranch that was owned by the Lankershim wheat empire, which was under the guise of the Los Angeles Farm and Milling Company.

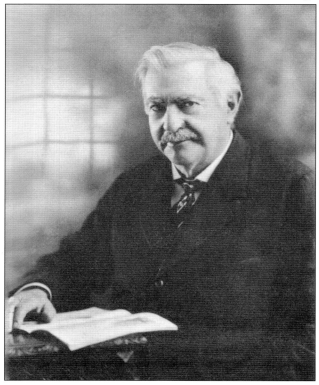

JOHN B. LANKERSHIM, 1920. As the son of Isaac Lankershim, John B. Lankershim formed a partnership with his father and Isaac Newton Van Nuys, and together they founded the Los Angeles Farm and Milling Association, which succeeded the San Fernando Farm Homestead Association. John formed a syndicate of independent ranches, which included the Workman, West, Patton, Home, Kester and Clyman wheat ranches. Together, these ranches cultivated 60,000 acres of grain that was processed in the first flourmill in Los Angeles in 1878. John established the town site of Toluca and later changed its name to Lankershim, California.

Three

THE NORTH VALLEY

George K. Porter and Charles Maclay founded the Porter Ranch by purchasing the entire northern Valley consisting of 56,000 acres. In 1879, Porter deeded a large interest to his cousin Benjamin F. Porter. The Porter Ranch was first developed in 1912, and by 1923 the land once owned by Benjamin F. Porter, which was on the south side of San Fernando Boulevard, developed into Sylmar Acres. The name Sylmar means "Sea of Trees."

Granada Hills is adjacent to the Porter Ranch and was the site of the historical Lopez Station. In 1927, the name Granada Hills was selected because the foothill community became reminiscent of the hills that surrounded Granada in Spain. Two of the Granada Hills attractions are the Knollwood Country Club and the Porter Valley Country Club. Mission Hills was primarily agricultural. With the coming of the Los Angeles Aqueduct, cultivation of orange groves became dominant in the area. In 1956, the designation "Mission Hills" was adopted. The Andres Pico Adobe is the most important historical landmark in Mission Hills. In the early 1890s, the Olive Growers Association of Los Angeles purchased 1,000 acres of the Maclay Rancho. By 1923, Sylmar olives became world famous, which enabled the major olive-packing plant of Sylmar to employ 400 employees. In 1915, the town was annexed to the City of Los Angeles. It is also home to Mission College and the Olive View Medical Center.

The City of San Fernando became San Fernando Valley's first independent city. The founding of the City of San Fernando was the result of the purchase of the north Valley by George K. Porter and Charles Maclay. On September 15, 1874, Maclay registered a township and called it "The City of San Fernando." On August 31, 1911, San Fernando became the second incorporated city in the Valley.

Pacoima is located on the Charles Maclay Ranch. The name "Pacoima" derives from the Indian term for "rushing waters." The main street of the new town was originally called Taylor Avenue, after Pres. Zachary Taylor, but was later changed to Pershing Boulevard. Today the main street is called Van Nuys Boulevard. For many decades, the farming area yielded crops of olives, peaches, apricots, oranges, and lemons. Pacoima is now known for the Hansen Dam Recreational Area, which is a flood control basin constructed in 1940.

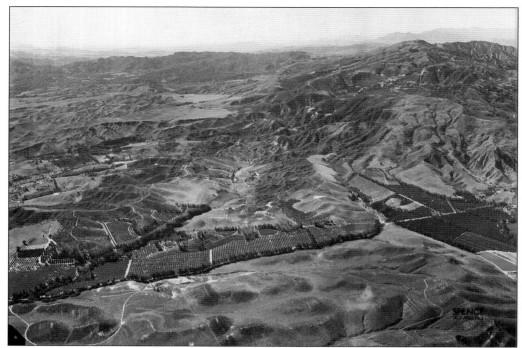

PORTER RANCH AND KNOLLWOOD, 1951. This aerial view looks west toward the northern end of Balboa Boulevard and the San Fernando Reservoir. This area was once part of the vast Ex-Mission Rancho San Fernando lands. Benjamin and George Porter later owned these rancho lands; their land encompassed Chatsworth Park, Hawk Ranch, Aliso Canyon, Lopez Station, and the San Fernando Mission. Balboa Boulevard is seen running north adjacent to the citrus groves.

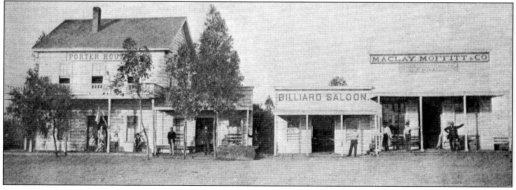

SAN FERNANDO, 1874. Pictured here are the Porter House, Billiard Saloon, and the Maclay-Moffitt & Co. building that housed the Wells Fargo office. State senator George K. Porter formed a partnership with retired state senator Charles Maclay, and together they bought 56,000 acres of San Fernando property. After the railroad was built in the Valley, their property was worth $150 per acre, which resulted in the rapid growth of their fledgling community.

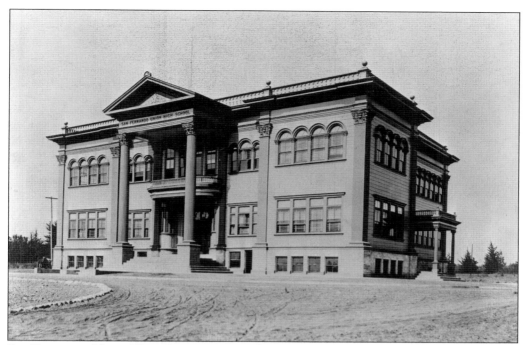

SAN FERNANDO UNION HIGH SCHOOL, 1909. The new San Fernando Union High School district was formed in 1896, and it included all north Valley school districts. Professor J.T. Anderson led the formation of the school and was the first principal. By 1909, the new San Fernando Union High School was built. The high school's building was designed in the classical style.

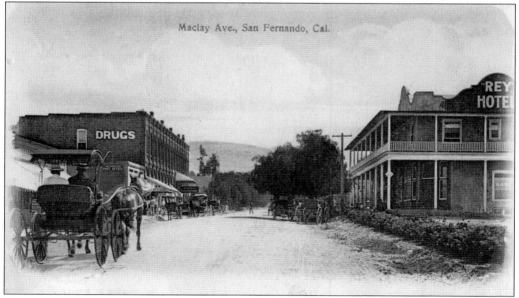

MACLAY AVENUE, SAN FERNANDO, 1911. This eastern view of Maclay Avenue shows the El Rey Hotel that was built in 1888, which functioned as a hotel, bank, real estate office, and billiard room within one brick building. On the other side of the street is the San Fernando post office and the town's drugstore.

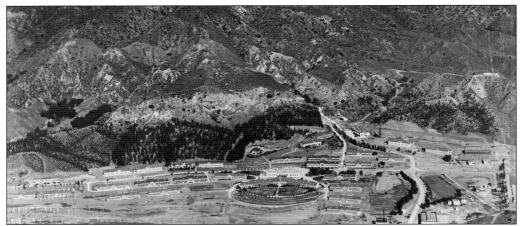

OLIVE VIEW SANITARIUM, 1925. Built in 1922 by the County of Los Angeles, the sanitarium was opened primarily for the treatment of tuberculosis. Small cottages were constructed on the 580-acre foothills of a former part of San Fernando, which later became Sylmar. By 1970, a new facility was built to replace the old sanitarium with Olive View Hospital.

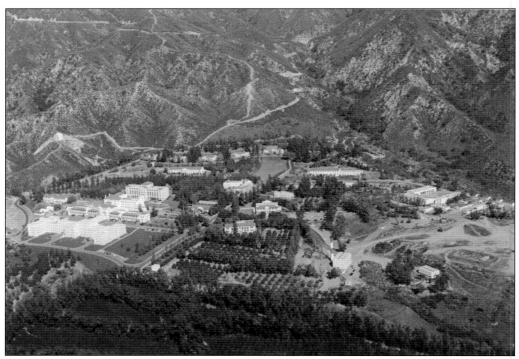

SAN FERNANDO VETERANS' HOSPITAL 1951. Overlooking the west Valley, the Veterans' Hospital was built on 66 acres of the US government's 700-acre property in San Fernando. There were 43 buildings on the property by 1948. Much of the campus was designed in the Spanish style of architecture. In 1926, it was built to take care of veterans of World War I. The entire facility was either damaged or destroyed in the 1971 earthquake, which resulted in turning the property into Veterans Memorial County Park in 1976.

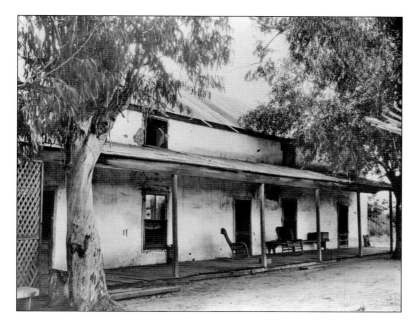

ANDRES PICO ADOBE, 1915. The construction of the Andres Pico Adobe began in 1834 by Don Andres Pico, who operated the Ex-Mission Rancho as a cattle ranch. Andres Pico turned over the house to his adopted son Romulo and his wife Catarina, who both lived there for many years. Known as Ranchita Romulo, the ranch house was rented to various families over the years until 1927.

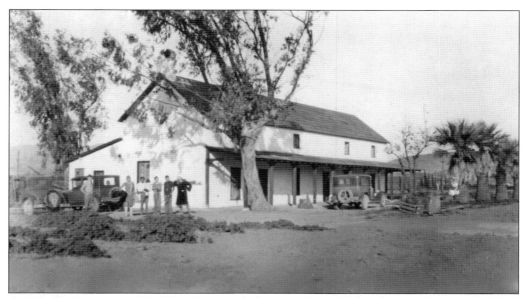

ANDRES PICO ADOBE, 1932. This photograph shows the Pico Adobe after its restoration by Mark R. Harrington. Harrington was the curator of the Southwest Museum in 1928. The adobe house started to deteriorate at the end of the 19th century. Harrington started restoration work around 1930, and rebuilt and restored the house into a Monterey-style ranch house. In 1968, the City of Los Angeles acquired the building. The San Fernando Valley Historical Society operates the adobe house, state landmark No. 362.

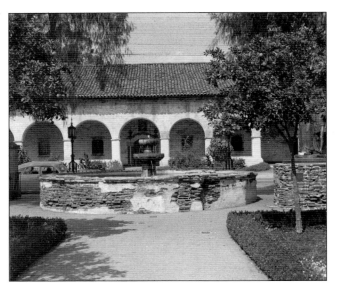

MISSION SAN FERNANDO REY DE ESPAÑA, 1950. The original mission's structures were built in 1797, and the Convento Building (or its arched building) was completed in 1822. The mission's fountain was once located in front of the Convento but was moved to a park that is separate from the mission, near San Fernando Mission Boulevard. The fountain was built in 1812 and was fashioned after one in Cordova, Spain. It was named the Memory Garden, and the fountain is placed near the statue of Father Serra with a Native American youth.

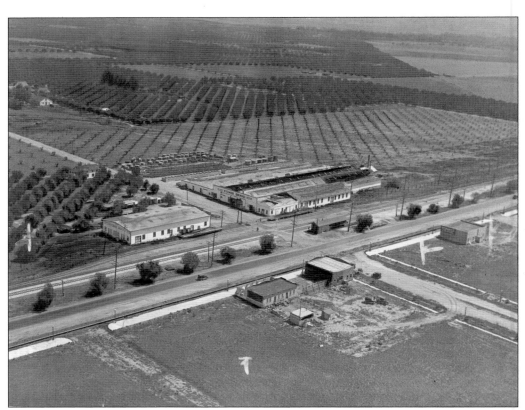

SYLMAR, 1929. In Sylmar, olive groves were located in the vast farmland, and olive farming dominated the northwest Valley. Sylmar Brand Company's production plant, where they cured, packed, canned, and bottled olives, was on San Fernando Road. In 1924, the factory was one of the major industries in the Valley and employed 400 workers to pickle olives and make olive oil.

SYLMAR, 1960. This view of Sylmar looks north towards the Sylmar Pass, which today is the Golden State I-5 Freeway. There were still olive groves in Sylmar at this time. The photograph also shows a portion of Granada Hills, Sepulveda Boulevard on the left, San Fernando Road on the right, and Roxford Street in the center. The open land outlined in the center is where Bendix Aviation Corporation built its facility in 1962.

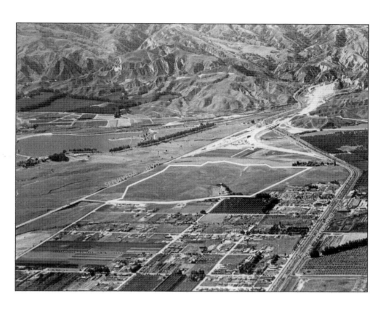

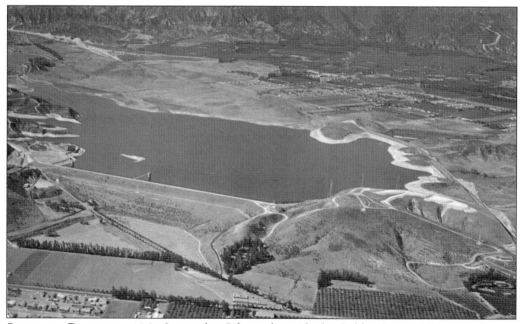

SEPULVEDA RESERVOIR, 1961. Located in Sylmar alongside the Golden State I-5 Freeway, the San Fernando Reservoir was built as part of the Los Angeles Aqueduct project in 1913. It is one-and-a-half-miles long and holds around seven-and-a-half-billion gallons of water. By 1961, the reservoir was called the Sepulveda Reservoir, and by 1962 it was taken over by the Department of Water and Power, which renamed the reservoir Van Norman Lakes.

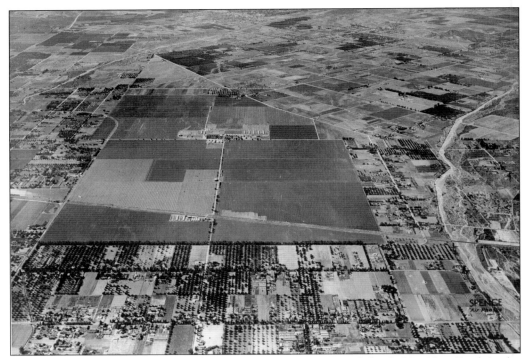

PANORAMA RANCH, 1937. Looking north over the Panorama Ranch lands, Van Nuys Boulevard is at the far left, Woodman Avenue is at center, and the Tujunga Wash is at the far right. Panorama City's transition from grazing and farm lands to a thriving self-contained community happened in just a few short years. The name came from the original Panorama Ranch, which was a cattle and dairy district in the Valley.

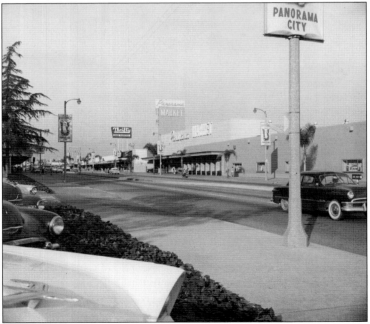

PANORAMA CITY, 1955. The Panorama Market was located north of Van Nuys Boulevard. The market opened in May 1950, and became the first supermarket in Panorama City. In autumn 1948, much of the Panorama Ranch was ready for subdivision and was transformed into a residential community. Together with churches, schools, playgrounds, and a shopping center, the new Panorama City became one of the first modern communities in the Valley.

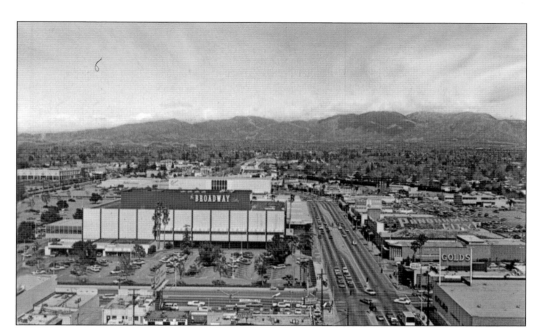

PANORAMA CITY, 1977. This aerial view of northern Panorama City shows the business-and-residential community at Roscoe and Van Nuys Boulevards. Where the Panorama Shopping Center stands, only 20 years earlier was nothing but orange and walnut groves. The new Broadway Valley store opened on October 4, 1955, in the shopping center complex. Honorary mayor-and-actor Walter Brennan officiated the opening ceremony.

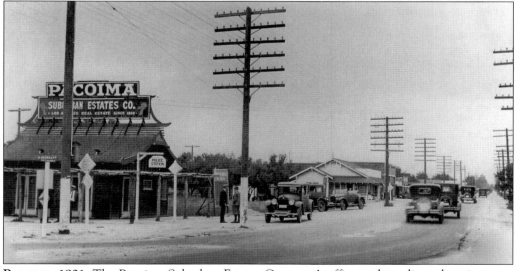

PACOIMA, 1931. The Pacoima Suburban Estates Company's office and a police substation were located at San Fernando Road and North Sherman Way. Pacoima was originally farmland owned by a real estate man named Jouett Allen. He purchased 1,000 acres and built a train depot for the business he hoped the Southern Pacific Railroad would bring. In the 1880s, the development began with the carving of streets for new neighborhoods. The main road later became known as Van Nuys Boulevard.

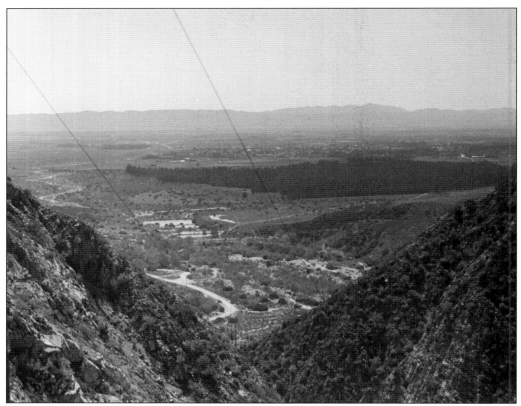

PACOIMA CANYON, 1958. The Pacoima Canyon has been a wilderness and recreation area since the 19th century. In 1905, the Pacoima Canyon Mountain Ranch catered to tourists who wanted to hunt or hike the hills. For many years, there were summer cabins in the canyon. Many were made with river stones from the Pacoima Wash. By 1926, work was under way on the Pacoima Dam, which was completed in February of 1929.

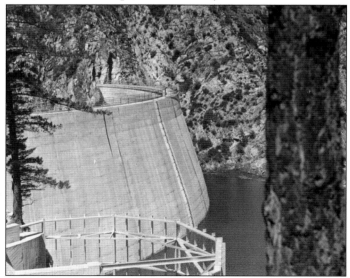

PACOIMA DAM, 1958. The planning of the Pacoima Dam and Reservoir began in 1920, and in 1924, actual construction began with the pouring of concrete. The dam was planned to be 375 feet high and 600 feet long across the top. The base was planned to be 65 feet wide and 100 feet thick, and the architectural plan designed it as a radial arch. When the dam was completed in 1929, it held 12,000 acre-feet of water, which backed up the canyon for 3.5 miles and created an artificial lake.

Four

THE EAST VALLEY

Arleta became its own community in the late 1960s. In 1954, the post office in Arleta opened; it was a substation of the Pacoima Station. Shadow Hills remained rural and undeveloped for many years because it was located in the gravel-and-rock quarry zone. Lake View Terrace is adjacent to Sunland-Tujunga, and around 1880, settlers came to the area to grow vineyards for wine production. In 1940, the Hansen Dam was built on the site where Lake Holiday was once located.

Around the 1880s, Sun Valley was originally known as Roberts, which was the name of a general store and the only business in the area. During the same decade, the Southern Pacific Railroad laid its tracks through what is now Sunland Boulevard and San Fernando Road. In 1896, a robbery incident led to renaming the town as Roscoe, California. The name survived until 1948, when it was subsequently changed to Sun Valley. In 1909, rock quarries were established in and around the Tujunga Wash. In 1913, film director Cecil B. DeMille came to Roscoe and filmed his first film, *The Squaw Man*. In 1920, actor Douglas Fairbanks Sr. built sets for *The Mark of Zorro* at the foothill by Stonehurst Avenue and Sunland Boulevard.

The City of Los Angeles first annexed Sunland in June 1926. Tujunga needed firefighters, and a deal was made for Los Angeles to install firefighters in the area, which created a Sunland-Tujunga district. In 1934, Columbia Pictures used Sunland as its location for the film *It Happened One Night*, which starred Clark Gable and Claudette Colbert. The City of Tujunga derived its name from the Gabrielino Indian village of the same name. In 1907, a socialist utopia was founded in Tujunga. In the 1920s, Tujunga was home to Sen. John Steven McGroarty, who in 1923 built his own home and named it Rancho Chupa Rosa. Today, it is registered as No. 63 of the Historic-Cultural Monuments in Los Angeles. The most famous resident from Tujunga was film director Cecil B. DeMille. DeMille named his ranch Paradise Ranch; it was located in the Little Tujunga Canyon. Burbank was a part of Rancho San Rafael that the Spanish crown granted to Cpl. Jose Maria Verdugo in 1797. When Verdugo died in 1830, he willed the property to his two children. Years later, the two children sold a major portion of the rancho to Jonathan Scott. Around 1867, Scott sold part of the subdivided land to Dr. David Burbank. Burbank became the first independent city in the Valley, incorporated on July 1, 1911.

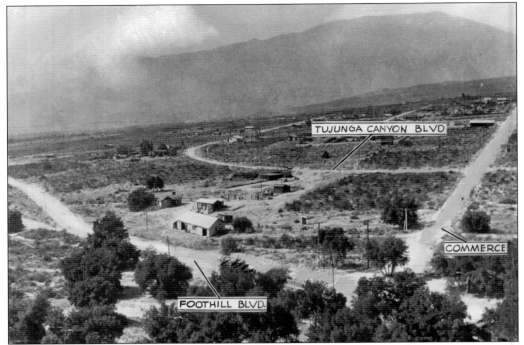

AERIAL VIEW OF TUJUNGA, 1915. This photograph shows an early view of Tujunga, portraying the Tujunga Canyon Boulevard, Foothill Boulevard, and Commerce Avenue that leads northwest. At this time, there were only a few small ranches and homesteads in the dry foothills that were filled with dirt roads and oak trees.

TUJUNGA, 1915. In this photograph, Bolton Hall is on the right. It was built in 1913 from local river rock. The building began as a community center and was Tujunga City Hall for a brief time. Bolton Hall was dedicated in August 1913, and it still stands today as a historical monument and museum operated by the Little Landers Historical Society.

TUJUNGA, 1929. The original Tujunga Fire and Police Department was located at 123 Valmont Street and Samoa Avenue. Opened in 1929, the station served areas around the Tujunga Wash, Roscoe (Sun Valley), and Pacoima. Pictured from left to right are police chief Earl Bruner, John Lambert, and fire chief Harry Rice.

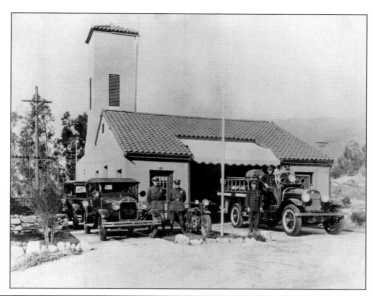

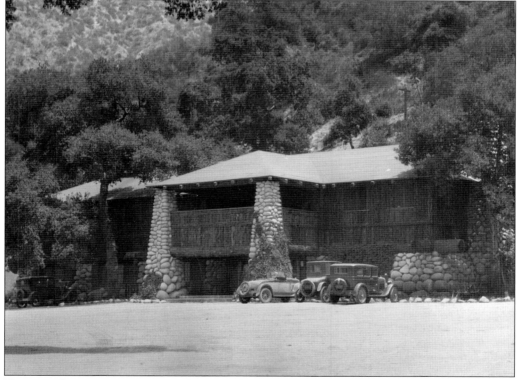

TUJUNGA CANYON, 1931. Pictured in this photograph is the "Lodge" on the Hanson Ranch in Tujunga Canyon. The Hansen Ranch became a Los Angeles County Park and recreation area in July 1931. It had recreational facilities such as two tennis courts, a swimming pool, playground, picnicking tables, and camping spots. The Lodge was turned into a public clubhouse for parties and meetings. It was originally built as the ranch house for the Hansen family, and was constructed as a log cabin with a river-rock design that was common for the area.

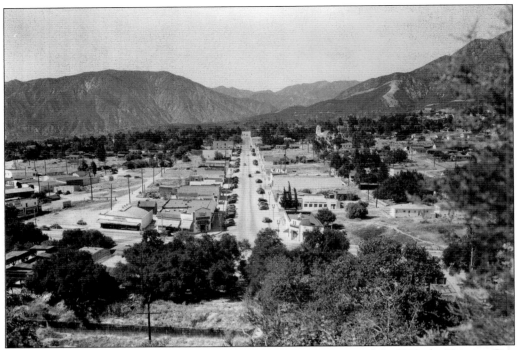

Tujunga Valley, 1936. On April 21, 1925, Tujunga was incorporated. In 1929, the Tujunga City Council established zones where sanitariums for tubercular patients could be built. Tujunga was known as the "health community" and "Little Switzerland." Although Tujunga was a small town during the 1930s, it had its own Bank of America, Tujunga Hardware, Tujunga Market, Tujunga Drugstore, Oasis Café, and the *Record-Ledger Newspaper*, all of which were located on Tujunga Canyon Boulevard. On March 7, 1932, Tujunga was annexed to the City of Los Angeles.

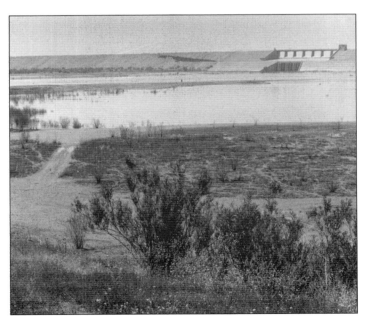

Hansen Dam, 1958. Construction of the Hansen Dam started on September 1, 1938, and was completed on August 6, 1940. It was an important barrier that protected the northeast Valley from serious flooding, as the Big and Little Tujunga Rivers were nearby. At this time, the dam was described as a "compacted earth-fill structure with a maximum height of 122 feet and a length of 10,500 feet extending from the west end of the Verdugo Mountains to the low foothills of the San Gabriel Mountains."

SUNLAND, 1934. During the Great Depression, Sunland was a village with Foothill Boulevard as its main street. The automobile club described Sunland as a place to take a recreational drive. There was camping and an auto motel in the town, which catered to tourists. On Fenwick Street, there was Aronstein's Market and Tavern, which served refreshments from milk to beer. For many years, the old oak trees dominated the streets in Sunland, which gave the town a mountain-resort environment.

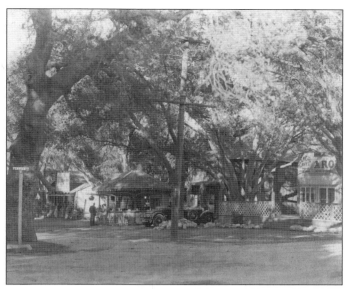

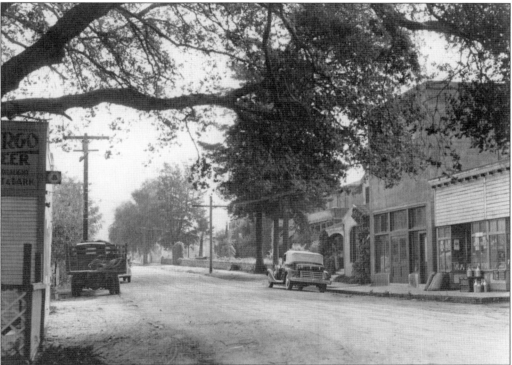

FENWICK STREET, 1934. This photograph shows the corner of Fenwick Street and Oak Tree Way. The Sunland Market was located at 8538 Fenwick Street. Throughout the 1920s and 1930s, hunting lodges were built in the area, but after World War II, many of the old lodges were converted into houses for employees of the aerospace industries nearby. After Tujunga became a city in 1925, there was a movement to annex Sunland, but the idea was rejected. One of the town's main industries was packing olives from local trees. The Monte Vista Park (which is now Sunland Park) became a picnic area with a motel nearby for travelers.

STARS IN SUNLAND, 1934. The location department from Columbia Pictures chose Sunland as the small town setting they needed for the film *It Happened One Night*, which starred Clark Gable and Claudette Colbert. The film company used a nearby motel for the scenes where Gable and Colbert stayed overnight during a rainstorm. In this photograph, Walter Connolly and Colbert are in a scene outside a storefront that was converted into a constable's office. It is located at 8538 Fenwick Street.

SUNLAND-TUJUNGA, 1940. The Verdugo Hills High School was located at 10625 Plainview Avenue on the border between Sunland and Tujunga. The school officially opened on September 13, 1937. The high school was built on the site of a lemon grove that was next to the original Plainview Avenue Elementary School. Verdugo Hills is known for its junior and high school status in the Los Angeles City School District.

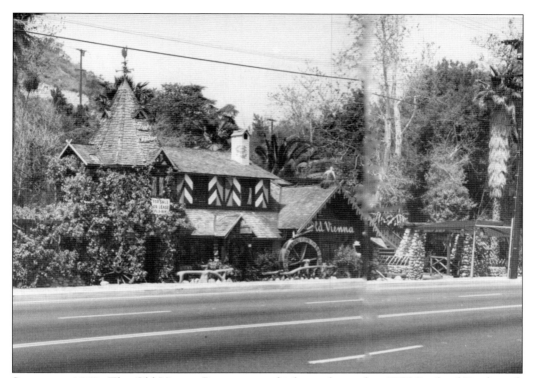

Sunland, 1962. The Old Vienna Restaurant, which was located at 9955 Sunland Boulevard, became popular with the German and Austrian colony ever since it was opened in 1937. Its owner August Furst built a stone castle on a hill above the restaurant building. The grounds consisted of gardens, patios, duck ponds, and an "Old World" restaurant building, which was built in Swiss chalet–style architecture.

Open Road in Burbank, 1889. This photograph shows a southeast view of Olive Street and the open farmlands. The Southern Pacific acquired the rights for its north-to-south line through the area in 1873. In 1887, during the Los Angeles economic boom, Burbank began to grow. In 1908, a newspaper was established, and the first bank was opened. By 1911, the city was officially incorporated.

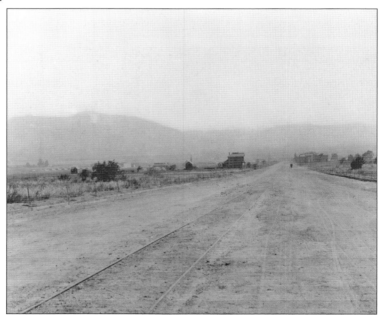

BURBANK, 1905. The Burbank Ranch nestled in the foothills of the Hollywood Hills alongside the Los Angeles River. On this site, the First National Film Corporation built its unique sound film studio in 1926, which was merged with Warner Bros. Studios in 1928.

BURBANK, 1926. This image shows Dr. David Burbank's ranch house, which was built on the Burbank Ranch, the location of the present-day Warner Bros. Studios. In 1908, Frank Martin originally built the ranch house. At the time, the ranch was mainly raising sheep. The Martin family farmed 40 acres for many years but later sold their property to First National Pictures in 1926.

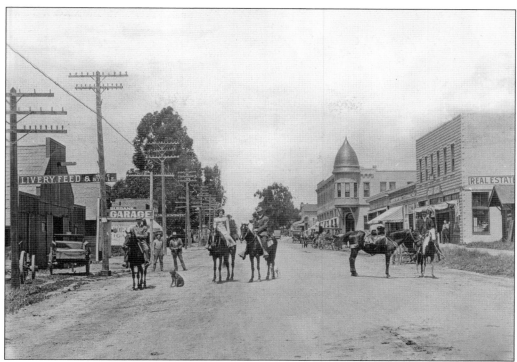

BURBANK, 1911. This photograph shows the corner of San Fernando Boulevard and Olive Street. The dome structure on the right is the Burbank block office and real estate building. During 1911, some of the businesses on the downtown block were O.C. Lane's Burbank Garage, Sylvester and Goodenow's Hardware Store, and Thomas Story's Livery and Feed Stable. There were also two real estate offices, a general-merchandise department store, a hotel, and a barbershop.

BURBANK, 1919. At the corner of Glenoaks and Angelino Avenues there were many businesses, such as the L.W. Garage, O.C. Lane Garage, a club lunchroom, a department store, a hotel, and a drug store. Down the block, the Moreland Truck manufacturer advertised with a banner that read, "Moreland Locates New Factories in Burbank." The Moreland Motor Truck Company built a major truck factory at San Fernando Boulevard and Alameda Street, which opened in March 1920.

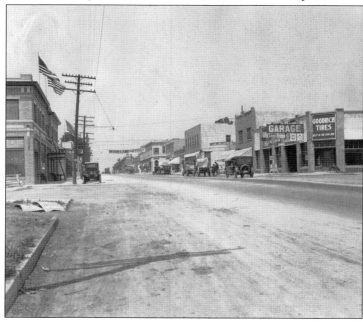

BURBANK, 1920. This aerial southern view over the Barham Pass shows an area that was known as "Dark Canyon." Barham Boulevard merges with Pass Avenue at the Burbank Ranch. To the right is the backlot of Universal Studios, which was located alongside the Los Angeles River. To the far right is Cahuenga Pass. The photograph also shows the cultivated fields of the Burbank Ranch, which is currently the site of Warner Bros. Studios.

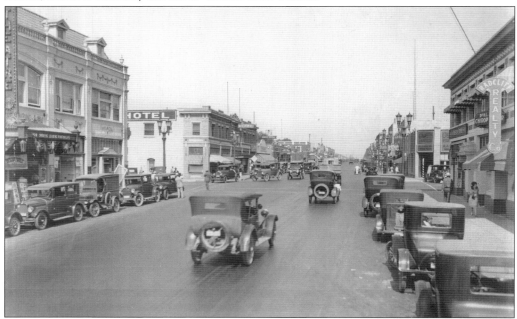

BURBANK, 1927. This image shows the corner of San Fernando Road and Angeleno Avenue. The Burbank Hotel and Victory Theatre building are located on the left side of the photograph. At the time, the Victory Theatre showed the film *Desert Gold* by Paramount Pictures. The Elizabeth Hotel, one of the older hotels in Burbank, is located on Angeleno Avenue as well.

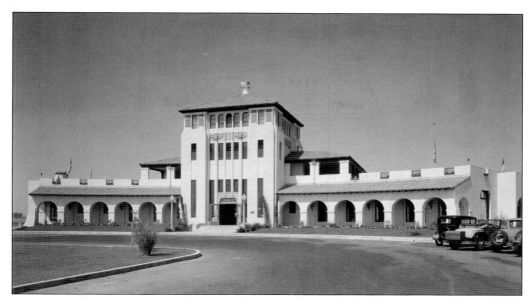

UNION AIR TERMINAL, 1934. This Spanish-style terminal building opened in 1929 and served the newly constructed United Airport, which was later opened on May 30, 1930. In June 1934, the airport became the Union Air Terminal. The airport changed management and was renamed the Lockheed Air Terminal in 1940. It was later renamed the Hollywood-Burbank Airport in 1967. The airport changed its name again to the Burbank-Glendale-Pasadena Airport in 1979, and finally in December 2003, it was renamed Bob Hope Airport.

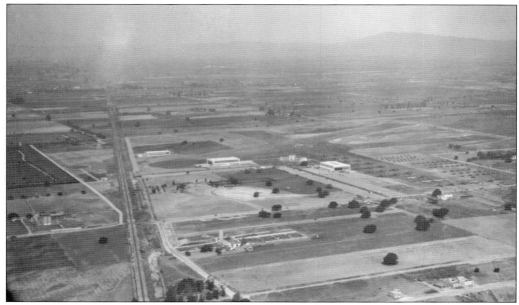

BURBANK UNION AIRPORT, 1934. Originally, the present-day airport was established in 1928 along the Union Pacific Railroad's line at Hollywood Way, which is now Vanowen Street, by the Boeing Air Transport Company. The United Air Transport Company quickly became a partner with Boeing, and the airport was named the Boeing-United Field. By 1930, the name was changed to United Airport and then renamed Union Airport in 1934.

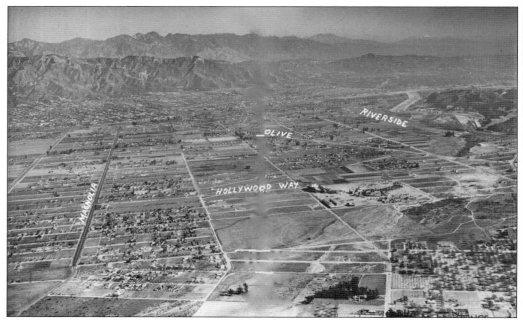

BURBANK, 1936. This photograph shows a northeastern view of Magnolia Boulevard (left), Hollywood Way (center), Olive Avenue (upper center), and Riverside Drive (upper right). The Columbia Ranch (center right) was the location of a few sets from the film *Lost Horizon*, which was being made at this time.

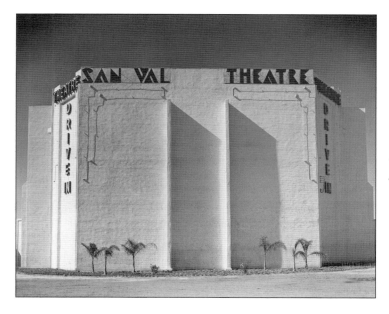

SAN VAL THEATRE DRIVE-IN, 1938. This drive-in theater was once located at 2720 Winona Avenue, which was west of San Fernando Boulevard. In 1938, the San Val was the second drive-in theater built in California. The architect Clifford A. Balch designed the movie theater in Streamline Moderne style. For many years, the Pacific Theatres Corporation operated the drive-in, but it closed down in the mid-1970s.

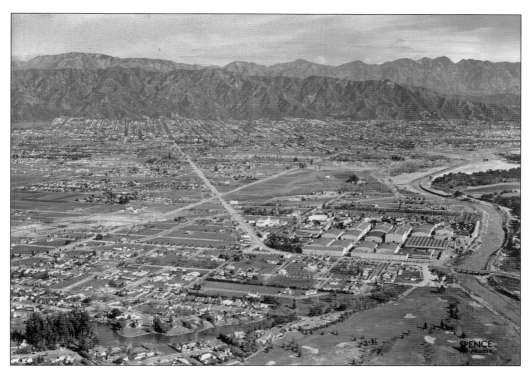

BURBANK, 1939. This aerial photograph shows a northeastern view of Toluca Lake. It also shows a portion of the Lakeside Golf Course (at the bottom) and Warner Bros. Studios (at the right). The Los Angeles River winds along the southern border of Burbank. Olive Avenue is the main street that runs diagonally across the center of the photograph, intersecting Alameda Avenue.

LOCKHEED AIRCRAFT FACTORY, 1941. Lockheed Aircraft employed over 24,000 people at its plant in Burbank. In 1928, the plant was built at the intersection of San Fernando Road and Turkey Crossing. The factory changed ownership several times, but it kept its operations in Burbank. During World War II, the factory employed 94,000 people and produced B-17 bombers and P-38 fighters.

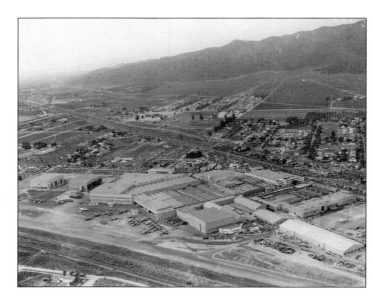

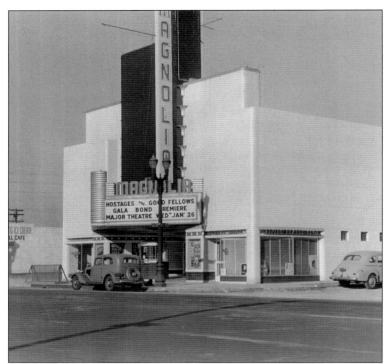

MAGNOLIA THEATRE, 1944. In 1929, the architect Jacques de Forest Griffin designed the Magnolia Theatre with a modified-French style. He topped the building with a 170-foot pylon that was inspired by the Eiffel Tower. The theater was located at 4403 West Magnolia Boulevard on the corner of Hollywood Way. The Magnolia Theatre was one of Burbank's theater landmarks. Its auditorium seated 737 people. It closed down in 1979, but it was later remodeled into a recording studio.

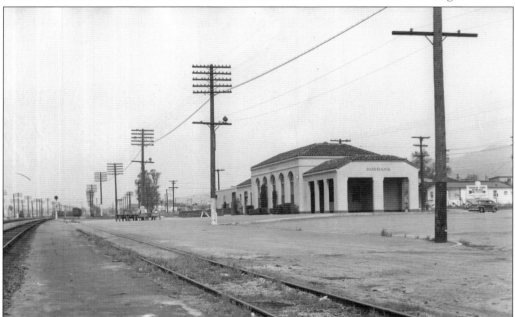

BURBANK RAILROAD STATION, 1949. The Southern Pacific Railway station opened in Burbank in 1887, and in 1923, it was replaced. In later years, a new station was built on the original depot site on Front Street between Olive Avenue and Magnolia Boulevard. The new Spanish-style building housed a passenger waiting room, ticket office, and freight department. On June 15, 1930, the first Southern Pacific train stopped at the new depot.

BURBANK THEATRE, 1952. The Burbank
Theatre seated 547 people, and its new
building was located on San Fernando
Boulevard. It opened with the film
Snows of Kilimanjaro, and was a first-run
theatre. It was said that the Burbank
Theatre was on the site of the old
Victory Theatre, which was located at
207 South San Fernando Boulevard.

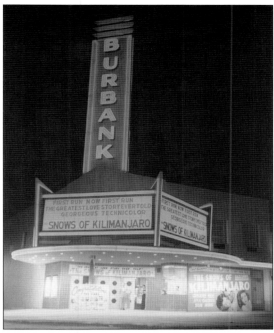

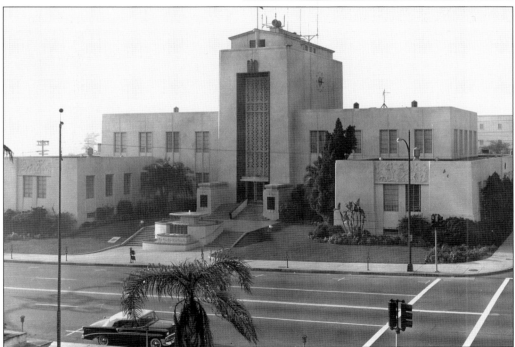

BURBANK CITY HALL, 1956. On April 18, 1996, the Burbank City Hall was placed on the national
and state Register of Historical Resources. In 1999, the City of Burbank restored city hall with its
Streamline Moderne–style from 1941. The city and the Burbank Heritage Commission placed a
plaque in the building. There were three original murals inside the building: *The Four Freedoms*
in the council chamber, *Burbank Industry*, and *Justice* in the lobby of the city attorney's office.

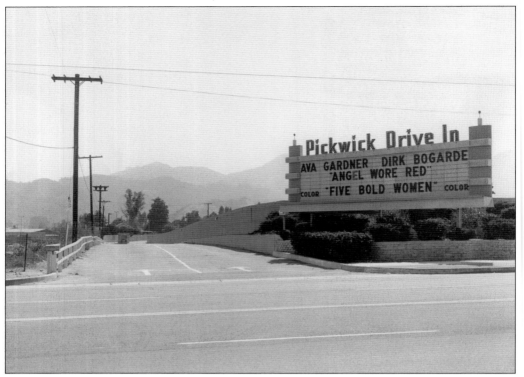

PICKWICK DRIVE-IN, 1960. This drive-in theater opened in 1949, with space for 781 cars. It was located at 1100 West Alameda Avenue and had an entrance on Riverside Drive. The drive-in was one of several in the San Fernando Valley. For years, the Pacific Theatres Corporation operated it. The Pickwick Drive-In was the location of Mel Brooks's premiere for *Blazing Saddles*. Warner Bros. hosted the premiere, and the guests entered on horses. Due to lack of ticket sales, the theater closed and was torn down in 1989.

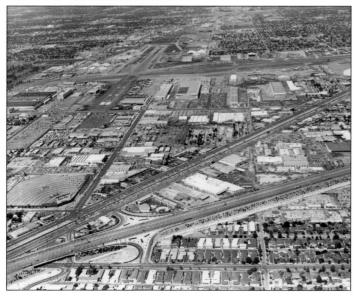

BURBANK, 1965. This aerial image shows a northern view over the Golden State I-5 Freeway and San Fernando Boulevard, which leads to Lockheed Airport. At bottom left is the San Val Drive-In Theatre, which was located at 2720 Winona Avenue. As a result of the development of the aviation industry, the Lockheed Air Terminal subsidiary operated the Burbank Airport until 1978. At this time, the airport was sold to an airport authority and was renamed the Burbank-Glendale-Pasadena Airport.

Five

THE SOUTH VALLEY

Universal City's most important landmark is Campo de Cahuenga, the location where the Capitulation of Cahuenga was signed on January 13, 1847. In 1914, the Universal Film Manufacturing Company moved from its previous studio lot, which was east of Barham Boulevard, to Lankershim Boulevard to the west. In 1869, North Hollywood began when Isaac Lankershim and Isaac Newton Van Nuys bought the entire southern half of the Valley, which included present-day North Hollywood and Universal City. In 1923, Lankershim was annexed to Los Angeles. The name North Hollywood was adopted in 1927. Valley Village was formerly a southern section of North Hollywood and was officially designated in February 1991. The North Hollywood area was a part of the James B. Lankershim ranch, annexed to Los Angeles in 1915. In 1939, residents called their part of North Hollywood "Valley Village."

In 1888, Isaac's son John B. Lankershim established Toluca Lake, and the township of Toluca. He later changed the name from Toluca to Lankershim in 1896; the new name was recognized in 1905. In autumn 1923, the present Toluca Lake flourished as a 152-acre ranch, which was purchased for the construction of the Lakeside Country Club. Studio City was once the western part of the Lankershim. On July 29, 1926, there were plans for a studio called the Central Motion Picture District. It was built in a newly organized town, which was named Studio City. Sherman Oaks was known as Valley of the Oaks, and by 1910, the Los Angeles Suburban Homes Company purchased 47,500 acres. In 1927, Moses Sherman subdivided his property, which became the present-day community of Encino. Originally, Encino was the site of ancient springs, which still exist in front of Don Vicente de la Osa's ranch house, located at Los Encinos. In January 1851, the US Land Commission approved the final title for all of Encino. Tarzana was named after writer Edgar Rice Burrough's jungle hero, Tarzan. In 1911, Gen. Harrison Gray Otis, who was the publisher of the *Los Angeles Times*, purchased 550 acres. In 1918, the Otis land was sold to Burroughs. Tarzana became the home to Adohr Milk Farms, the Braemar Country Club, and the El Caballero Country Club, which was built on the site of the Burroughs Estate.

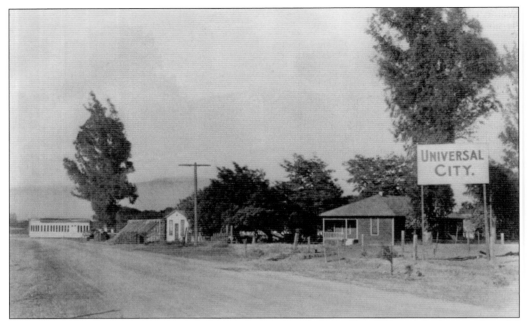

NEW UNIVERSAL CITY, 1914. Looking north up Lankershim Boulevard towards the Los Angeles River, the first permanent Universal Studio buildings are under construction. Before Universal Film Mfg. Company purchased the former Taylor Ranch on Lankershim Boulevard, the area was part of the Providencia Rancho and was later divided into various ranches by the turn of the century. Between 1870 and 1910, this part of the Rancho was known as the Lankershim/ Clyman Ranch.

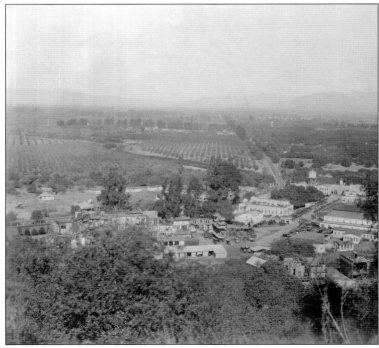

UNIVERSAL CITY, 1920. This aerial photograph shows a northern view of Universal Studios and Lankershim Boulevard as it passes along the Los Angeles River and citrus groves. Universal Studios purchased several ranches and expanded their property from the western border of Lankershim Boulevard to the eastern border of Barham Boulevard. The administration center was located on Lankershim Boulevard, and it had small backlots with both open and enclosed stages.

WEDDINGTON BROS. STORE, 1905. This general merchandise store was located on the southwest corner of Lankershim and Chandler Boulevards. The Weddington brothers were early pioneers of North Hollywood. The Weddington family called their establishment the Pioneer Store. The family installed a post office in the store; it was later moved to Universal City. In 1907, Guy Weddington purchased the Bonner Fruit Company and expanded its cannery into the largest employer in the town.

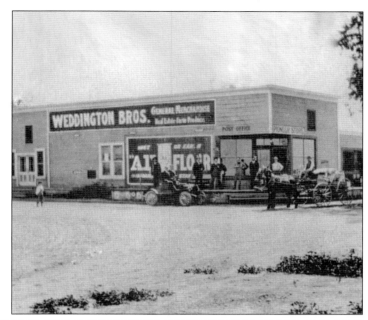

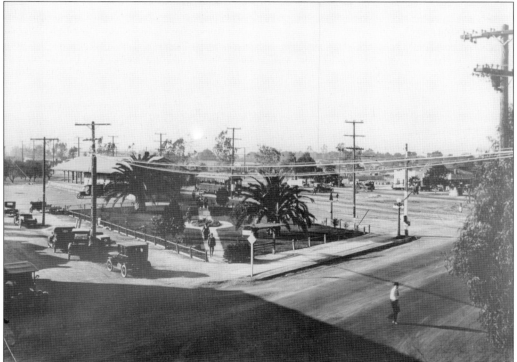

North Hollywood Park and Station, 1915. In 1911, the Pacific Electric Railway introduced rail services and ran its line through the Cahuenga Pass to Lankershim Station, which was located at Chandler Boulevard, the meeting point between Pacific Electric tracks and Southern Pacific tracks. The station and park became the heart of North Hollywood's social life, and many town concerts and events were held there.

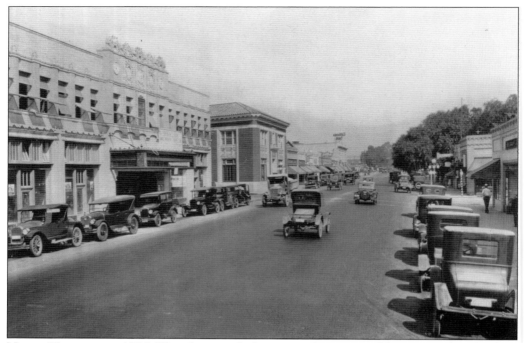

NORTH HOLLYWOOD, 1926. This photograph shows a northern view of the corner of Lankershim Boulevard and Weddington Street, which was where the original Weddington Ranch was located. The El Portal Theatre is on the left; the photograph was taken just before its opening in late 1926. The theater was on the site of the old Weddington ranch house. Originally, the theater was built as a vaudeville house, but later was converted into a movie house. It closed in the 1980s. The architect L.A. Smith designed the Spanish Baroque–style building, which was rebuilt and restored in the late 1990s and reopened in January of 2000.

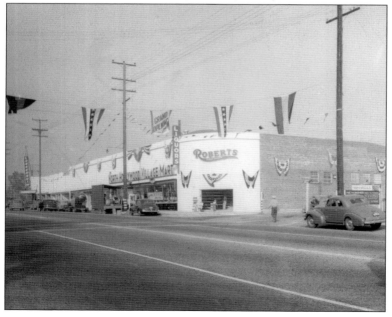

NORTH HOLLYWOOD, 1941. The newly opened North Hollywood Village Mart was located on the 7500 block of Lankershim Boulevard at Cohasset Street. The market was one of the pre-war shopping centers built in North Hollywood. They were considered "supermarkets," and were the first built in the Los Angeles area that serviced the new tracts of homes.

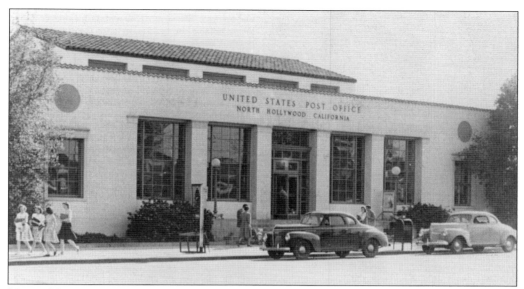

NORTH HOLLYWOOD POST OFFICE, 1942. In January 1936, it was announced that a new post office in North Hollywood would be built on Chandler Boulevard. The contract for the construction was awarded to the Brunzell & Jacobson Company. The ground dimensions for the new building were approximately 95 feet by 80 feet; it cost $72,789 to build. The new post office opened on October 17, 1936.

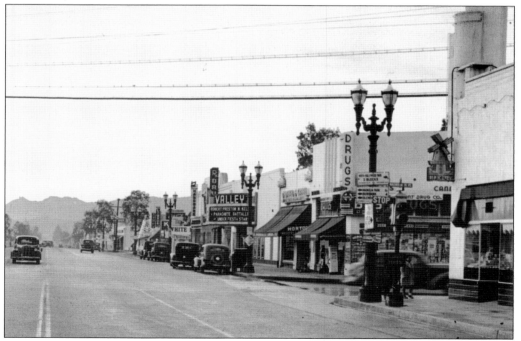

NORTH HOLLYWOOD, 1942. This photograph shows the south view of the intersection of Lankershim and Magnolia Boulevards. The Valley Theatre marquee is advertising the film *Parachute Battalion*. The theater opened in late 1941, and had a large stage to accommodate the meetings of garden clubs and other civic organizations.

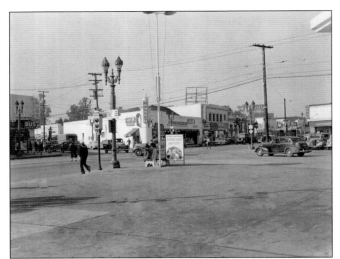

NORTH HOLLYWOOD, 1946. This image shows the intersection of Lankershim and Magnolia Boulevards. On the left, the Merchants Pharmacy building and the Santa Fe bus depot are on the corner. The Fitzsimmons Market was on the northwest corner. The Mid-City Drug Store, Western Union, California Bank, and Thrifty Drug Store were located up the block, and on the northeast corner was Hale's Pharmacy.

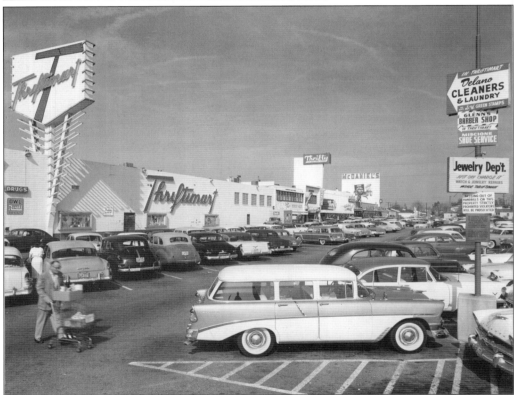

VALLEY PLAZA SHOPPING CENTER, 1956. Construction for this shopping center started in August 1951, and several major chain companies built branches in North Hollywood. McDaniel's was one of the first to open at the new shopping center, which was located at 6657 Laurel Canyon Boulevard. The store opened on September 13, 1951. The Big Owl Market (Owl Drug Store Company) was the next to open. The new supermarket opened on November 1, 1951, and had an unusually artistic sign. Later, the name was changed to Thriftymart. The Thrifty Drug Store opened later in 1952.

VALLEY PLAZA TOWER, 1976. The Valley's landmark, standing at 165 feet, is the tallest building in the San Fernando Valley. The Valley Plaza Tower is located at 12160 Victory Boulevard. The 12-story building is just west of Laurel Canyon at Bellingham Avenue, and is near the Valley Plaza shopping center district. In July 1976, L.A. Federal Savings commissioned the bicentennial mural, which was painted by artist Steve Lakeman.

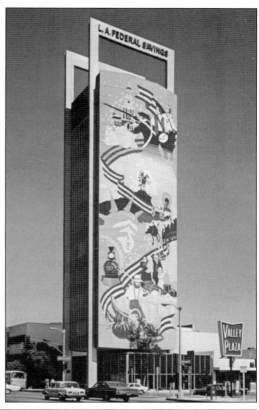

US POST OFFICE VALLEY VILLAGE STATION, 1989. This post office was originally assigned to both North Hollywood and Valley Village Station before the latter received its own postal code. The station was designated a landmark and was located at 12450 Magnolia Boulevard near Wilkinson Avenue since the early 1950s. The French Normandy–style building complements the neighboring buildings with shake roofs. The Valley Photo Service Camera Shop was on the corner of Whitsett Avenue and Magnolia Boulevard and opened in 1952.

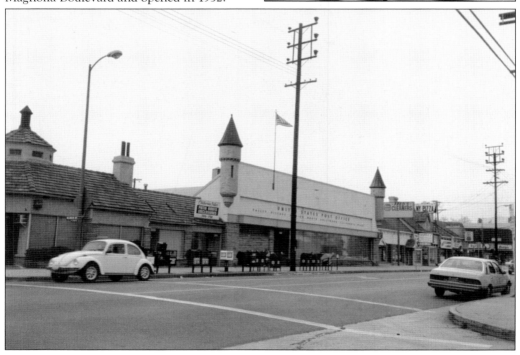

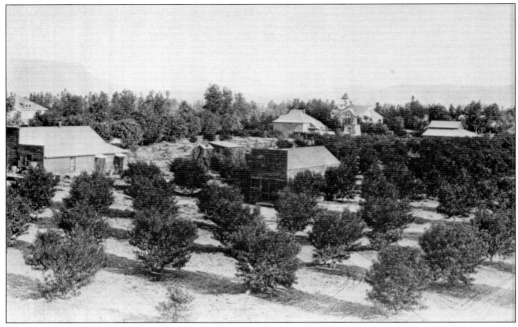

TOLUCA, 1893. The image above shows the Weddington Ranch, which was near the intersection of Lankershim and Magnolia Boulevards. The Weddington store is in the foreground. In the top center are the Weddington home and the Lankershim School (the Victorian-style house). Wilson C. Weddington became the postmaster of his town, which had a small post office, but was enough to put Toluca on the map. The Weddingtons came to Toluca in 1890 and eventually purchased around 32 acres.

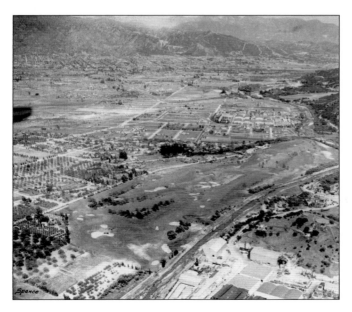

TOLUCA LAKE, 1949. This aerial view shows the Lakeside Country Club and the Toluca Lake residential district, which is adjacent to the golf course and south of the Warner Bros. Studios. The Universal Studios backlot is seen at bottom right. The residents changed the name of their community from Toluca to North Hollywood in 1927, and then changed it to Toluca Lake Park in 1929. The small section between Burbank and North Hollywood became Toluca Lake. The Lakeside Country Club opened officially in 1925.

LAKESIDE COUNTRY CLUB, 1936. The Lakeside Country Club officially opened on May 30, 1926. The club president, James Irsfeld, designated film director Frank Borzage, George L. Eastman, Frank Lloyd, and Lynn Reynolds to take care of the entertainment. The architect Max Behr designed the golf course, which was laid out on 138 acres of former ranchland. On September 15, 1925, members officially inaugurated the course.

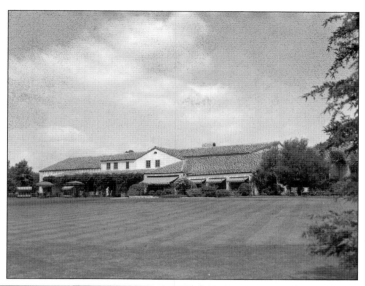

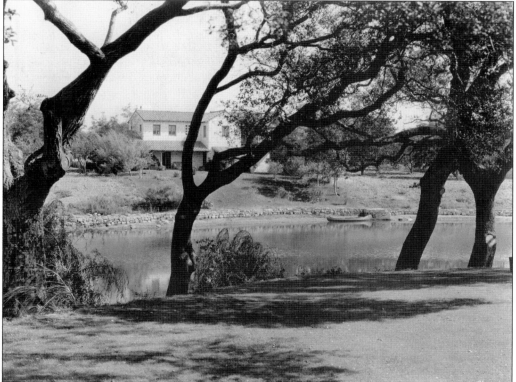

TOLUCA LAKE, 1925. This photograph shows land that was originally on the former Forman Toluca Ranch. In 1923, a group of investors purchased 125 acres and began to subdivide the property into Toluca Lake Park. Toluca Lake Park was sold as an exclusive residential development with a lake, park, and beautiful homes that were adjacent to the Lakeside Country Club. The first home on Toluca Lake belonged to aviator Amelia Earhart and then actor Richard Arlen. Other homeowners who followed Arlen included Bing Crosby and Bob Hope in the 1930s.

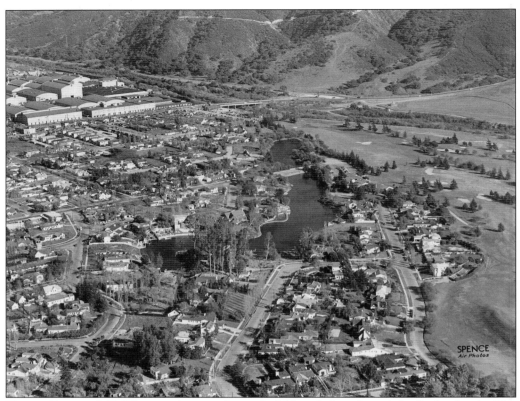

Toluca Lake, 1947. This aerial image shows the Toluca Lake side and the Burbank side. The original boundaries of Toluca Lake were Cahuenga Boulevard, Clybourn Avenue, Camarillo Street, and the Los Angeles River. There were many stars who lived in Toluca Lake, including Frank Sinatra, director Henry King, Oliver Hardy, Roy Disney, Dorothy Lamour, and Andy Griffith. Many other stars lived in the area as well. The Warner Bros. Studios and the Barham Bridge are nearby, at top left.

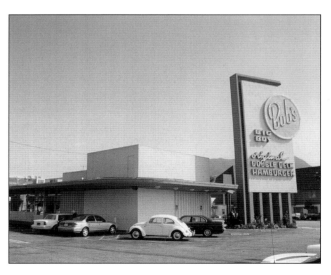

Toluca Lake and Burbank, 1998. This photograph shows Bob's Big Boy restaurant, which was located at 4211 Riverside Drive. Local residents Scott MacDonald and Ward Albert built the restaurant in 1949, and architect Wayne McAllister designed it in the Streamline Moderne style. The iconic restaurant was designated a California Point of Historical Interest. Over the years, some of the regulars included Bob Hope, Mickey Rooney, Debbie Reynolds, and Bing Crosby.

NORTH HOLLYWOOD, 1919. This photograph shows a southeastern view of Laurel Canyon, Ventura Boulevard, and Whitsett Avenue. The area is now the site of the Studio City Golf Course, which is located on the northwest corner of Whitsett Avenue and Laurel Canyon Boulevard. The former North Hollywood district went under redevelopment in 1926. The citrus groves and agricultural fields in the photograph were transformed into a new community called Studio City.

HOLLYWOOD COUNTRY CLUB, 1925. On January 1, 1920, a golf course was built at Ventura Boulevard and Coldwater Canyon Boulevard. In 1923, the development of the Hollywood Country Club started in the hills above the golf course. In 1937, the remaining 22-acre site of the Hollywood Country Club was sold to the Harvard School for Boys. In 1964, the Harvard School expanded its property with the construction of new buildings, an academic center, residence halls, dining hall, and swim gym.

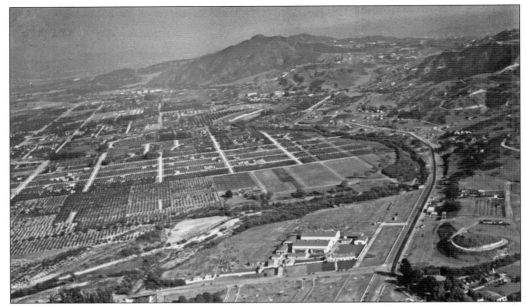

STUDIO CITY, 1928. This aerial photograph shows an eastern view along Ventura Boulevard toward the Cahuenga Pass. At the bottom are the Mack Sennett Studios, which were located at Radford Drive and Ventura Boulevard. Film producers Al and Charles Christie joined with the Central Motion Picture District Association to develop a motion picture studio and community. By 1927, Ventura Boulevard was widened, telephone service was extended, and an electric transmission station was built to serve the new district.

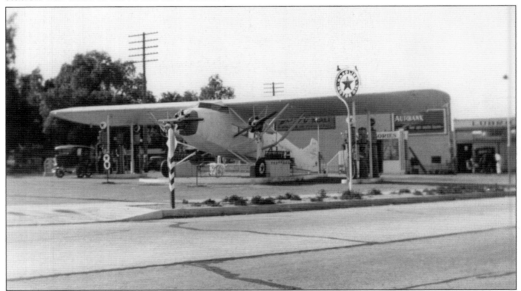

TEXACO'S ALBATROSS SERVICE STATION, 1933. The Albatross Service Station was located at the intersection between Ventura Boulevard and Ventura Place. Since the early 1930s, the Texaco Albatross (Airplane) Service Station was a landmark in Studio City. However, it disappeared in the 1950s. At this time, Texaco advertised its motor oil and aviation gasoline with Capt. Frank Hawks as their iconic figure. In 1931, Hawks flew from Los Angeles to New York in his "Texaco 13."

STUDIO CITY THEATRE, 1938. This photograph shows the Studio City Theatre, which opened in 1938 at 12136 Ventura Boulevard. On its opening day, the theater had a display of neon lights that dramatically announced Studio City's first and only movie theater. The Gore brothers and Adolph Ramish, who were associates in the theater enterprise, hired the architect Clifford A. Balch to design the Streamline Moderne–style building. When it opened, the theater seated 880 people and had a beautiful minimalist interior.

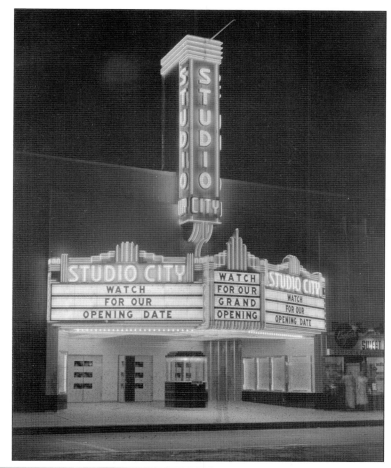

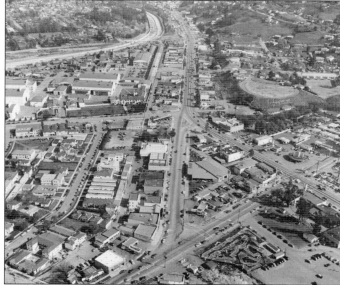

STUDIO CITY, 1940. This aerial image shows an eastern view along Ventura and Laurel Canyon Boulevards. The popular landmarks around the area during this time included Studio City Miniature Golf, Curries Ice Cream, Herbert's Drive-In Restaurant, Studio City Ford, and the Texaco Albatross Service Station. During the late 1930s and 1940s, architects and residents alike continued the development of Studio City, filling in the empty home sites and business properties along Ventura Boulevard.

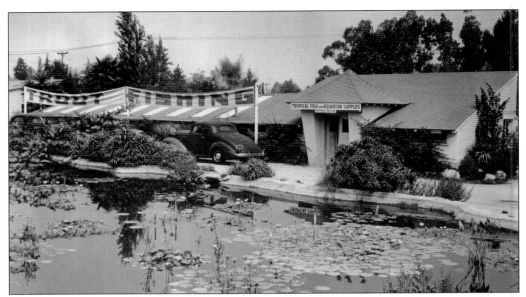

SPORTSMEN'S LODGE TROUT POND, 1946. The Bross Brothers Rustic Dining Room was located at 12833 Ventura Boulevard just east of Coldwater Canyon and had trout ponds. By 1946, Dave Harlig and his partner Raymond Fine purchased the restaurant and fishing ponds. The restaurant was considered a novelty, as a customer could fish for trout and then cook it on the spot. On December 31, 1946, the Sportsman's Lodge and Trout Fishing concession opened.

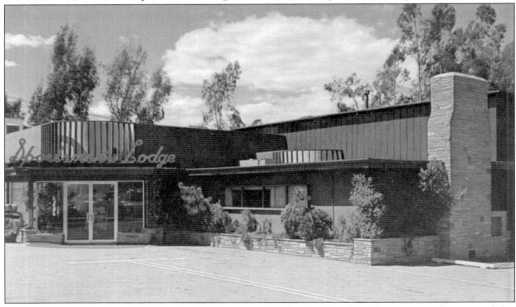

SPORTSMEN'S LODGE, 1958. The "Lodge" became a Valley landmark and many stars frequented the restaurant. For example, Clark Gable, John Wayne, Bette Davis, Kirk Douglas, and Tom Selleck were seen routinely at the Lodge. Many celebrities of the 1930s and 1940s met regularly for social events at the Lodge. By 1954, the Sportsmen's Lodge had two scenic banquet rooms that could accommodate 50 to 400 people. In September 1962, the Sportsmen's Lodge Hotel opened. The five-story hotel was built adjacent to the Lodge restaurant.

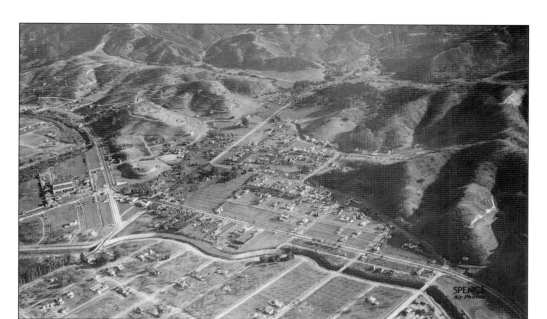

STUDIO CITY, 1935. This aerial image shows a southeastern view of the intersection of Laurel Canyon and Ventura Boulevards. Studio City's business district was dependent on the studio in this photograph because the city's economy was based on film production. When Republic Pictures Corporation absorbed Mascot Pictures, the studio had a new resurgence of activity. Studio City thrived during this period of renewed film production.

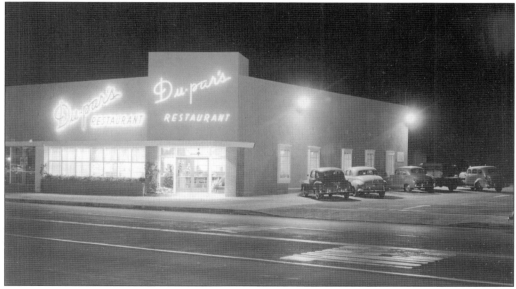

DU-PAR'S RESTAURANT 1948. James Dunn and Edward Parsons, who combined their surnames to create their restaurant's name, founded the first Du-par's restaurant at the Los Angeles Farmers Market in 1938. In 1948, Dunn and Parsons opened this new branch at 12036 Ventura Boulevard. The restaurant was across from the famous Texaco Albatross Service Station and Republic Pictures studios. Du-par's signage consisted of bright neon script above the front door and a backlit sign on the front of the building.

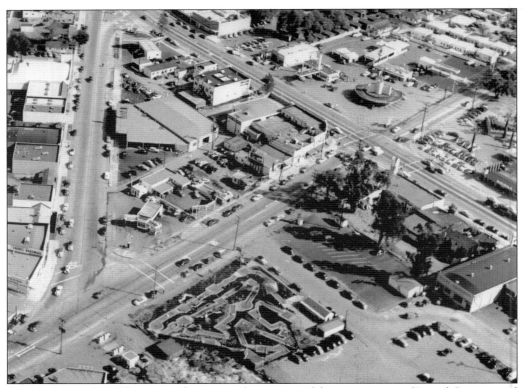

STUDIO CITY, 1949. This image shows a southeast view of the intersection of Laurel Canyon and Ventura Boulevards. Herbert's Drive-In Restaurant, with its round building, was located on the southeast corner of Ventura and Laurel Canyon Boulevards. Studio City Plaza is now located on the northwest corner, which was originally the location of Curries Ice Cream store, iconic for its giant ice-cream cone roof sign, and the old Studio City Miniature Golf Course, which is where Ralphs stands today.

TAIL O' THE COCK RESTAURANT, 1949. In January 1948, restaurateur Sheldon "Mac" McHenry opened a new restaurant in the former Remer's restaurant building and renamed it "Tail o' the Cock." It was located at 12950 Ventura Boulevard. The English-style restaurant became a Valley landmark. The new restaurant was a copy of the original on Restaurant Row in Beverly Hills. Many stars were regulars, including Clark Gable, Bette Davis, Humphrey Bogart, and Gene Autry.

STUDIO CITY, 1954. This is a view to the southeast from the intersection of Ventura and Laurel Canyon Boulevards. The Laurel Drive-In is on the southeast corner, with Walt Miller's "76" service station to the east of the restaurant. Du-par's restaurant is farther east on the south side of Ventura Boulevard. Today, a shopping mall with restaurants is located on the site.

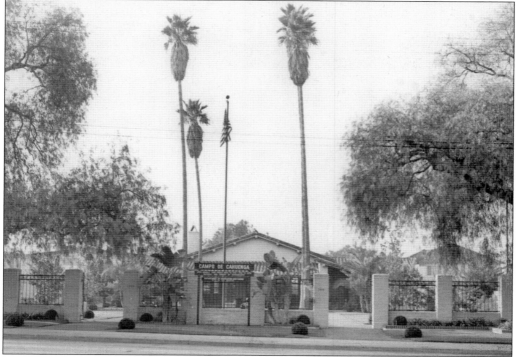

CAMPO DE CAHUNEGA, 1960. This historic landmark is the location where the Capitulation of Campo de Cahuenga was signed, which temporarily halted the Mexican-American War in California. It is located on Lankershim Boulevard. On January 13, 1847, Andres Pico, who represented the Californios, and John C. Fremont, who represented the Americans, signed the treaty. A marker across from Universal City identifies the specific area of the signing. The site was dedicated on November 2, 1950.

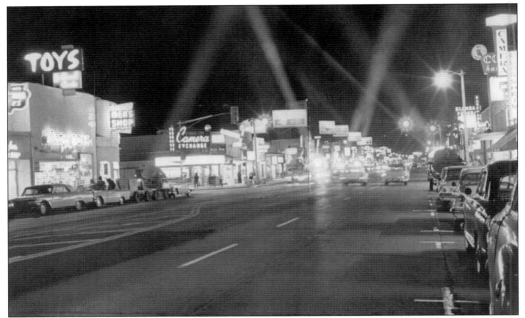

STUDIO CITY, 1962. This image shows a western view down Ventura Boulevard at Vantage Avenue. The Studio City Camera Exchange, in the center, was a city landmark since it moved to Vantage Avenue. Ben and Edith Thorsch founded the camera shop in 1944, which stocked everything a camera enthusiast needed. Their son Bernie owned and operated the shop until it closed.

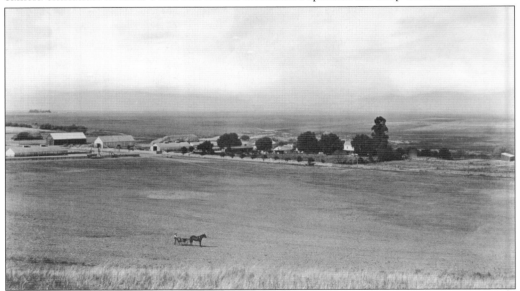

SHERMAN OAKS VICINITY, 1890. This photograph shows a northwestern view of open ranchland and farmland. It is possible that this might be the Kester Ranch, which was one of several ranching stations that cultivated wheat for the Los Angeles Farm and Milling Association. The Clyman Ranch was located at the east end, the Kester and Home ranches were in the center, and the Patton, West, and Workman ranches were in the west Valley. Each ranch had a main house, two smaller houses, a stable, grain house, blacksmith shop, and water well.

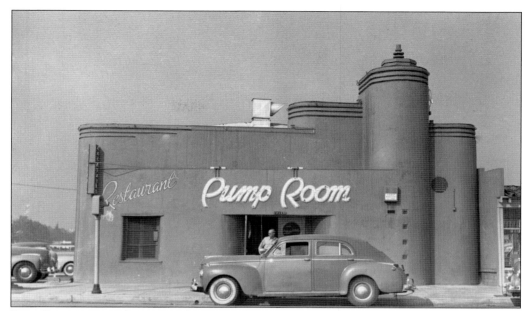

PUMP ROOM, 1949. Sherman Oaks's original Pump Room opened in a building at 14445 Ventura Boulevard. It later moved to its more famous location at 13003 Ventura Boulevard, just west of Coldwater Canyon Boulevard. For many years, the Pump Room was a popular Valley restaurant patronized by local residents for parties and meetings. It was also a place where customers could see celebrities until it closed in the 1980s.

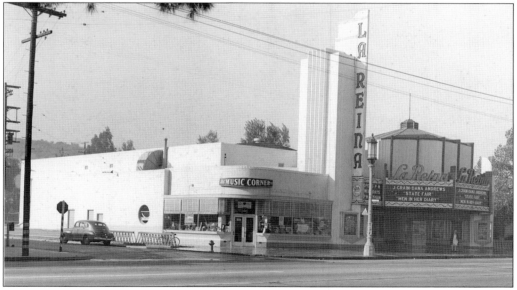

LA REINA THEATRE, 1938. La Reina was one of the most beautiful theaters in the San Fernando Valley in Sherman Oaks. It opened in 1938 at 14626 Ventura Boulevard. La Reina Theatre had a neon exterior and was designed as a Streamline Moderne–style building. Its name means "queen" in Spanish. The theater was a mini-movie palace and was one of the most popular theaters in the Valley until it closed in 1987. Although the building now houses shops, its movie façade including the box office and terrazzo decorations remain.

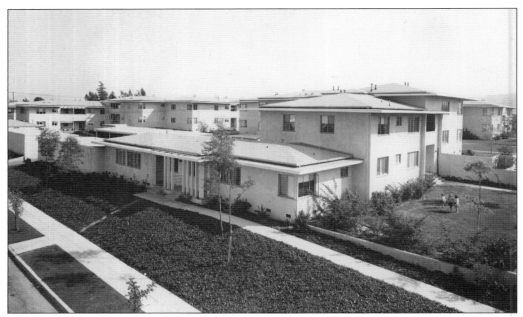

CHASE KNOLLS, 1952. Chase Knolls was a residential and rental development in Sherman Oaks that consisted of 19 buildings, which totaled 260 apartments, built in 1949–1950. The apartment complex was located at 4865 Fulton Avenue at Riverside Drive and opened in 1950. Designed by architects Heth Wharton and Ralph Vaughn, the buildings were integrated with lawns and garden courts that were landscaped with forest pines, jacaranda, and magnolia trees. The 20-acre site was originally the home of J.W. Chase, who purchased the site in 1909.

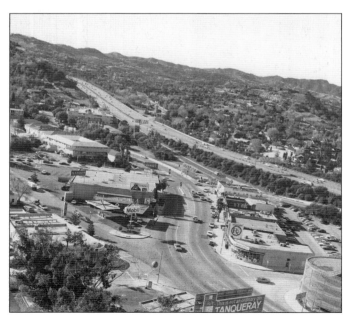

SHERMAN OAKS TO VALLEY OAKS, 1964. This photograph shows North Sepulveda Boulevard alongside the San Diego I-405 Freeway at the intersections of Valley Vista Boulevard and Woodcliff Road. This intersection had a complex of stores, which included Valley Oaks Pharmacy, Valley Oaks Cleaners, Westward Ho Market, and a neighborhood liquor store, and the Boys From Sicily pizzeria. All traffic from Ventura Boulevard, which headed to the San Diego Freeway, was diverted to Valley Oaks and led to the freeway on-ramps nearby.

ENCINO, 1939. This photograph shows Los Encinos Rancho, which was a homesite off of Ventura Boulevard. The lake and the Eugene Garnier Building were still surrounded by open farmland. At the time, Ventura Boulevard was being widened. Most of the dirt from the grading was spread out across the boulevard and covered the foundation of the old tavern that burned down in 1906.

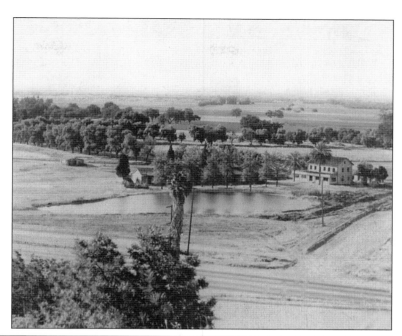

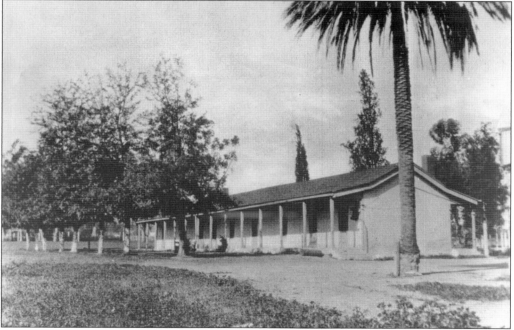

ADOBE LOS ENCINOS, 1859. The building above was built on the original El Encino Rancho. The land was passed to Tiburcio Cayo, later to Antonio Ortega, and then to Vicente de la Osa, who built a nine-room adobe in 1849. By 1859, de la Osa converted the house into an inn. Eugene Garnier purchased the rancho in 1868 and built a two-story limestone house. In 1877, the title passed to Gaston Oxarart, who owned the property until 1889. Then it was passed to Simon Francois Gless, who married Juanita Amestoy, the daughter of Domingo Amestoy. Juanita owned the ranch from 1889 to 1944.

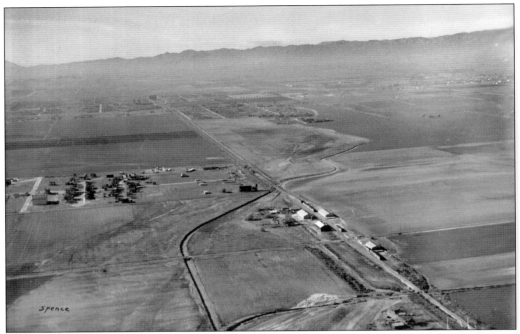

ENCINO, 1934. This image shows a western view of the open fields in Encino and the Southern Pacific Railway line running diagonally through the area. In the center is the Radio-Keith-Orpheum (RKO) Pictures Movie Ranch that was bordered by Amestoy Avenue, Louise Avenue, and Oxnard Street. The Los Angeles River whimsically cuts through the center of the photograph along Balboa Avenue. On June 28, 1916, the Amestoy Estate Company sold most of the property but retained 100 acres, which included buildings, the lake, and springs. W.H. Hay began to subdivide and develop the Encino area at this time.

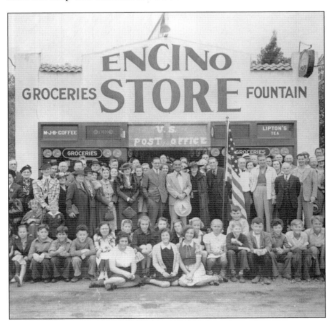

ENCINO STORE, 1940. The Encino Store was located at 17020 Ventura Boulevard near present-day Encino Park. At the time, the store had an official post office inside. This image shows a group celebrating the inauguration of Al Jolson as Encino's honorary mayor. Jolson is shown at center holding the hat. Mayor Jolson officiated at the opening of Encino's post office in 1938. Over the years, other celebrities became mayors of Encino, including the announcer Harry Von Zell and actress Amanda Blake of the television show *Gunsmoke*.

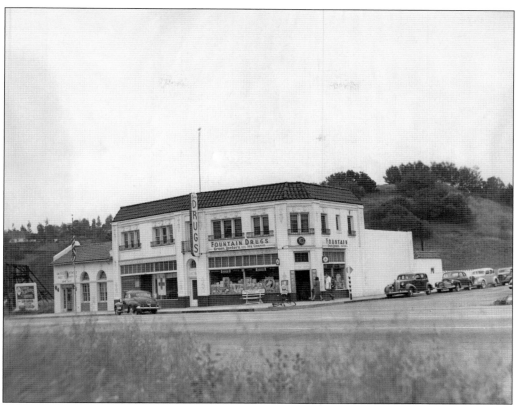

ENCINO, 1944. The post office in Encino was adjacent to the Encino Drugstore building at 16954 Ventura Boulevard near Genesta Avenue. For many years, the post office was located at the Encino Store, at 17020 Ventura Boulevard, until a new post office building was built.

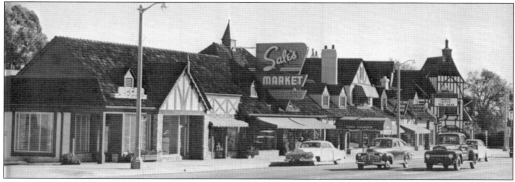

ENCINO, 1947. The image above shows Sale's Market on Ventura and Balboa Boulevards. M.L. Flowers designed the market in a French Medieval style. Between 1958 and 1959, Sale's Market was located at 17017 Ventura Boulevard. The Encino Book Store and the Loma Calhoun Women's Apparel Shop were both on the same block. By 1974, Sale's Market became Jurgensen's Grocery.

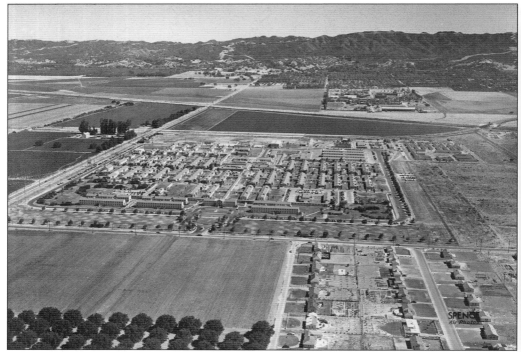

ENCINO, BALBOA PARK, AND VAN NUYS, 1948. This aerial image shows a southern view of the Birmingham Hospital, which was located at Vanowen Street and Balboa Boulevard. On the top right, the RKO Movie Ranch is seen in the background. The Birmingham Hospital was built between 1943 and 1944, and was the largest army hospital in the Los Angeles area. There were 80 buildings on the 111-acre site. By 1953, Birmingham Jr. High School had been leasing a portion of the property. In August 1954, the Los Angeles Board of Education received the deed of the property as a permanent school site. By 1960, the school system finalized the sale.

ENCINO, 1974. This image shows a western view at Ventura Boulevard and Genesta Avenue. Dean Witter & Co. had an office building on the southwest corner. Down the block was Monty's Steakhouse, one of the landmark restaurants in Encino. Farther down Ventura Boulevard near Amestoy Avenue was the Home Savings Building. Jurgensen's Grocery was across the street.

Tarzana Advertisement, 1922. The writer Edgar Rice Burroughs advertised his land development as a place to build a home in an artist's colony. However, the sales campaign did not work, and he later pursued a more traditional sales pitch. In 1922, developer Charles L. Daniels purchased 320 acres and began his own subdivision. He divided his land into one-acre parcels and used them for poultry ranches and berry farms. In 1923, Burroughs subdivided part of his acreage for houses.

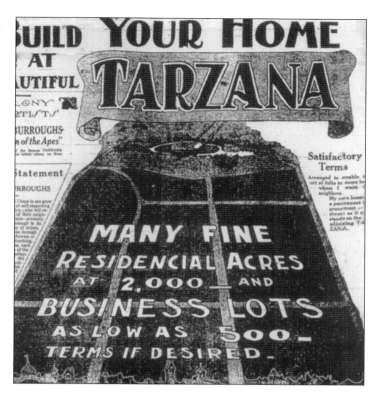

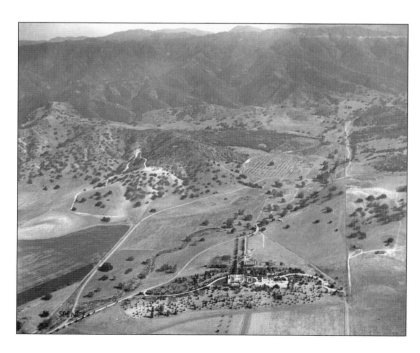

Tarzana, 1924. This aerial photograph shows a southern view of Burrough's estate and the surrounding Foothills property. It also shows a portion of Reseda Boulevard, which is the dirt road on the bottom right. The dirt roads above the estate were later known as Avenida Oriente Circle and Tarzana Drive. Burroughs purchased the 550-acre ranch in 1918.

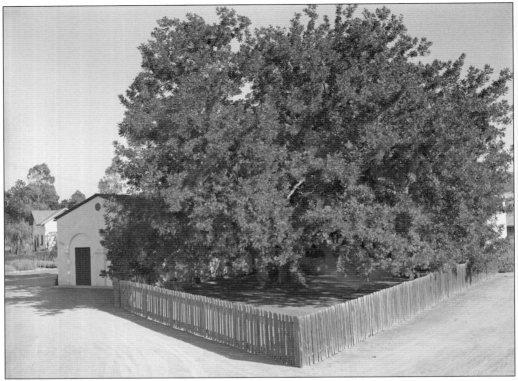

EDGAR RICE BURROUGHS OFFICE AND LIBRARY, 1939. In 1927, Burroughs's office was one of several addresses for his enterprises in Tarzana, established at 18352–18354 Ventura Boulevard. The Burroughs family eventually sold the estate, and the area became the Caballero Country Club.

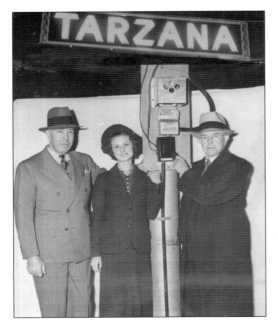

TARZANA, 1936. This photograph appeared in the *Los Angeles Times* in November 1936, announcing the lighting of a new Tarzana sign. The article read: "More than 1000 persons attended Tarzana's celebration last night when its new boulevard sign was lighted. Shown here are, left, Edgar Rice Burroughs, Miss Mabel Zerrahn, and Representative McGroarty, as the latter pulled the switch that lighted the sign, shown above."

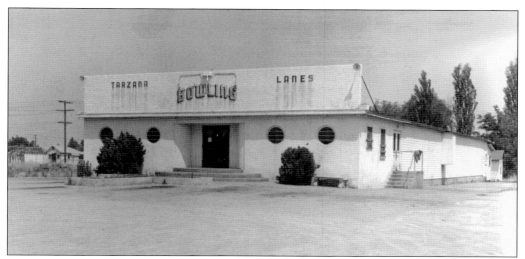

TARZANA, 1946. The Tarzana Bowling Lanes was on the 18000 block of Ventura Boulevard near Newcastle Avenue, adjacent to the famous Adohr Milk Farms in Tarzana. The bowling alley seemed to have existed from around 1946 to 1959. The Corbin Bowl was built in the 1960s and became Tarzana's premier bowling center.

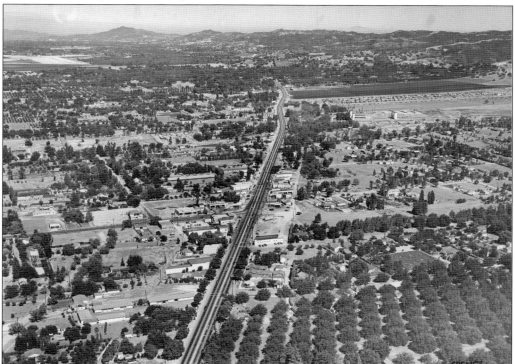

TARZANA, 1948. The aerial image above shows the east intersection of Ventura and Reseda Boulevards. At this time, Tarzana was a residential and farming community that dominated the area for over 100 years. On the bottom right, the citrus groves were cultivated alongside the open farmland, on the top right. The largest industry in Tarzana at this time was Adohr Milk Farms, located on the 18000 block of Ventura Boulevard.

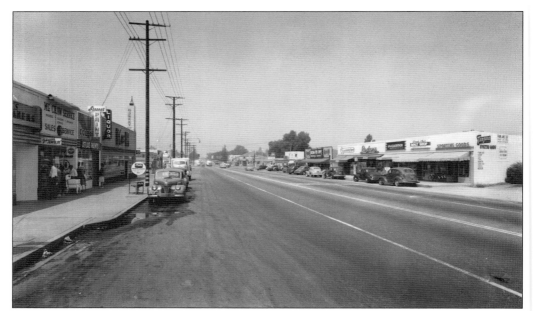

TARZANA, 1948. This photograph shows the view looking west toward the intersection of Ventura and Reseda Boulevards. On the south side of the street, the shops were McCraw Appliance Service, Atlas Paint Store, and K&M Market. On the north side of Ventura Boulevard, the shops were Tarzana Sporting Goods, Frank & Ann's Café, Village Cleaners, Roston's Yardage, Tarzana Variety Store, Tarzana Feed Supply, Beck Realty, and in the distance, Tarzana Pharmacy.

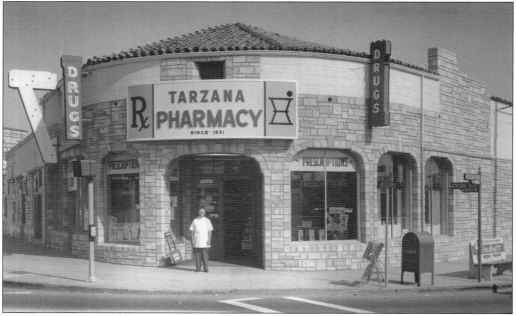

TARZANA PHARMACY, 1952. The pharmacy was the first building at the intersection of Reseda and Ventura Boulevards, built in February 1928. The pharmacy was located at 18501 Ventura Boulevard. The Tarzana Pharmacy was founded by the pharmacist and proprietor Harry Chariton. In 1965, Chariton celebrated his 35th consecutive year at the same location.

Six

THE WEST VALLEY

Woodland Hills was once a part of Rancho El Escorpion, which was owned by Miguel Leonis. Leonis, who was a Basque Spaniard, came to the Valley in 1858. He built the Leonis Adobe in 1865. Modern development of the area came in 1922, during the time Victor Girard Kleinberger founded the town of Girard. By 1941, the name was changed from Girard to Woodland Hills.

In the 1980s, a portion of the Warner Ranch was developed into the present-day Warner Center. Currently, Woodland Hills is the home of Los Angeles Pierce College. The City of Calabasas was named after La Canada de las Calabasas, which means "the canyon of the wild gourds." The word *calabasa* also means pumpkin, and it is spelled in Spanish as *calabaza*. Calabasas's early history is tied to Miguel Leonis, the man who established the area of Woodland Hills. Calabasas was officially registered as a city in 1991. The City of Calabasas has a historical district called Old Town Calabasas.

Hidden Hills is a residential district that maintained horseback trails and a rural-western heritage. Hidden Hills was originally 1,000 acres and was purchased in 1949. The first two-model homes were built in 1950 at 23704 Long Valley Road and 23629 Long Valley Road. The latter house was first purchased by Leo Gorcy, whose former nickname was "Dead End Kid." Early advertising described Hidden Hills as a place where you could "own your own rancho." In 1956, Lamond Chamberlain was the second developer of Hidden Hills.

West Hills was founded in 1988. The area was formerly a part of Canoga Park. In 1912, the Chumash people sold Rancho El Escorpion to George Platt. Platt established a dairy operation in the rancho and changed the name of the area several times, from Ferndale, Escorpion, and then finally to Cloverdale Dairy. In 1958, the rancho was incorporated into the City of Los Angeles.

In 1909, Canoga Park's Van Nuys Ranch was purchased by the Los Angeles Suburban Home Company. The purchasers included Harry Chandler, Harrison Gray Otis, Moses Sherman, and Hobart Johnstone Whitley. The area was known as "Owensmouth" and was founded on March 30, 1912. In 1930, Owensmouth was renamed Canoga Park.

Chatsworth was originally known as Chatsworth Park. On March 10, 1888, the original development map was registered in the Los Angeles County Recorder's Office, which marked the official beginning of the town. Chatsworth also has two of the largest parks in the Valley, the Santa Susana Pass State Historic Park and Chatsworth Park in the south.

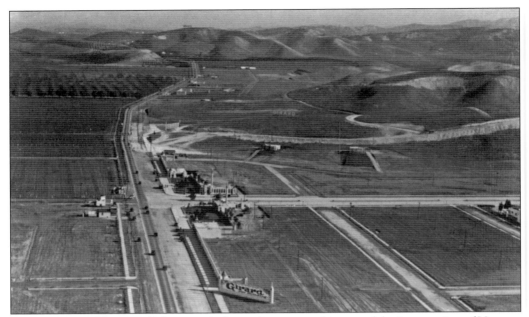

GIRARD, 1924. This aerial photograph shows the view to the west of the intersection of Ventura and Topanga Canyon Boulevards. The small village of Girard became Woodland Hills. In 1923, and over the next 17 years, Woodland Hills was known as the town of Girard. In 1925, the Girard Golf Course was established and later became the Woodland Hills Country Club.

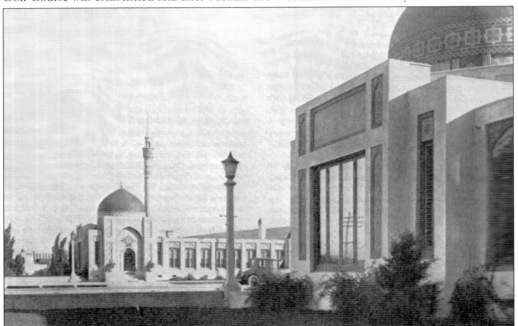

GIRARD, 1925. Victor Girard built these mosque façades as an attraction that helped sell property in the new development. It was located on the north side of Ventura Boulevard. The mosque entryway was located at Topanga Canyon Boulevard. The mosques were a landmark in the area for a number of years.

WOODLAND HILLS, 1949.
This aerial image shows an
eastern view over Ventura
Boulevard and Topanga
Canyon Boulevard, which
is near the top of the
photograph. The streets
are, from bottom to top:
Woodlake Avenue, Gonzales
Drive, Canzonet Street,
Ostronic Drive, Leonora
Drive, Ryder Avenue,
Fallbrook Avenue, Ponce
Avenue, Sale Avenue,
Capistrano Avenue, and
Shoup Avenue. Burbank
Boulevard is in the center.

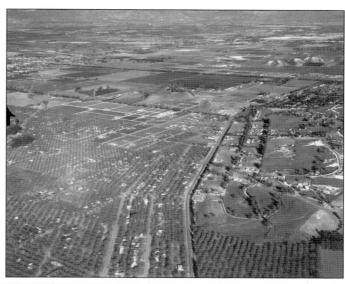

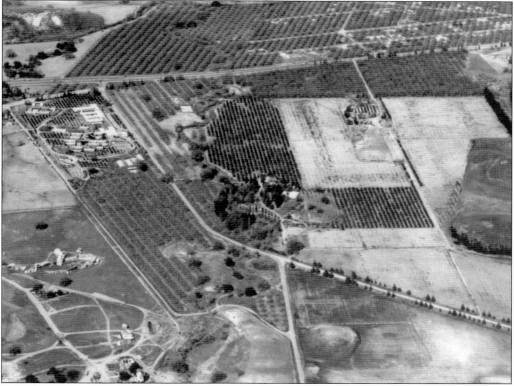

WOODLAND HILLS, 1951. This image shows a northern aerial view of Ventura Boulevard (top)
and Mulholland Drive (center). The photograph also shows a portion of the Warner Movie Ranch
on the bottom left and the Motion Picture & Television Fund (MPTF) Country Home on the
top left. At the center is the John Show Ranch House, which is on its own hill and overlooks
Ventura Boulevard. The MPTF Country Home was opened in 1941 on land purchased from John
Show Ranch House, which was once adjacent to the Warner Movie Ranch.

SAN FERNANDO GOLF CLUB, 1951. In 1923, the club was originally opened as the Girard Golf Club. However, it changed its name several times. Victor Girard started the Girard Golf Club to attract potential property buyers. By 1941, the name was changed to the Woodland Hills Golf Club. It changed again to the San Fernando Golf Club in 1951. For many years, the course was the home of the annual San Fernando Valley Golf Tournament. The club's 36-hole course was the site of many tournaments that were attended by golf stars and movie celebrities.

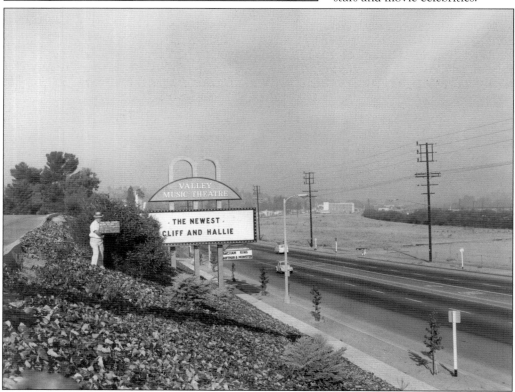

VALLEY MUSIC CENTER, 1966. The Valley Music Center was a 2,800-seat dome-shaped theater that opened in July 1964 with the musical *The Sound of Music*. The theater was located on the 20000 block of Ventura Boulevard between Winnetka and Canoga Avenues. The Valley Music Center became a landmark of Woodland Hills for many years. At this time, Warner Bros. Studios was filming the movie *The Cool Ones*, which starred Roddy McDowall, on location at the Valley Music Center.

WARNER RANCH, 1949. In 1935, the first 500 acres were purchased by Harry Warner of Warner Bros. Studios. Most of his property would be known as the "Warner Bros. Location Ranch," and eventually encompassed over 2,800 acres south of Ventura Boulevard, bordering on Calabasas. In this area, Harry raised Thoroughbred horses. He built his country home atop a knoll. During World War II, the ranch was used by the armed forces for training films.

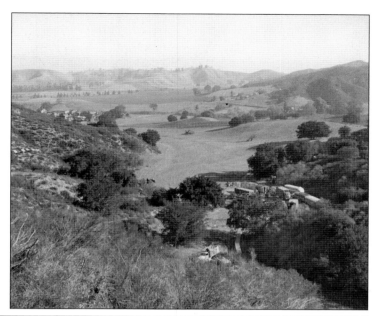

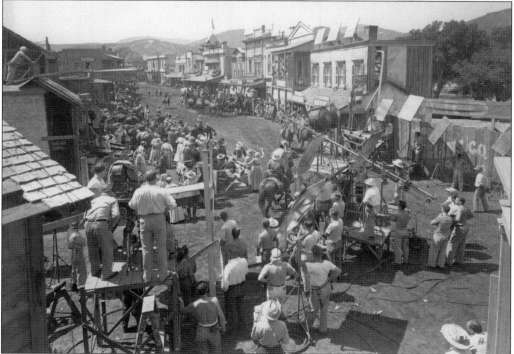

WARNER RANCH, 1947. This image shows a movie set at the Warner Ranch, which was located in the Woodland Hills and Calabasas area of the Valley. There were many outdoor sets built on the ranch that were used in various Warner films. This photograph shows a moment during the filming of *Pursued*, which was directed by Raoul Walsh and starred Teresa Wright, Robert Mitchum, Judith Anderson, Dean Jagger, and Alan Hale. Many other films used this western-town movie set, including *Dodge City* and *Virginia City*. Both films starred Errol Flynn.

LEONIS ADOBE, 1937. The Leonis Adobe Museum was built in 1844. On August 6, 1962, it was designated a Los Angeles Historic-Cultural Monument, labeled as No. 1. It was surrounded by the Calabasas Creek Park. The house was designed with Monterey-style architecture and landscaped with native plants including the great white oak tree, which could be several hundred years old. Another part of the Leonis Adobe Museum is the historical Victorian home known as Plummer House. Until it was moved to the Leonis Adobe grounds in 1983, the Plummer House stood in Plummer Park, West Hollywood, where it was known as the "Oldest House in Hollywood."

CALABASAS, 1955. This photograph shows a western view of Calabasas Road. Calabasas was the nearest town to the Warner Movie Ranch. The town was also known for its famous "Hanging Tree." The town was not subdivided until the death of Espiritu Leonis in 1906. In 1928, ground was broken for the Los Angeles Pet Memorial Park, which is the burial ground for Humphrey Bogart's dog Droopy and Charlie Chaplin's cat Boots. Calabasas's first subdivision was a 140-acre art colony called Park Moderne.

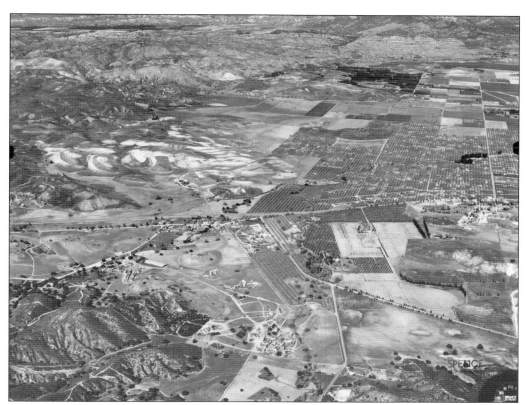

CALABASAS TO WOODLAND HILLS, 1950. This aerial view shows north Calabasas and Woodland Hills with Ventura Boulevard and Calabasas Road in the center. The Warner Movie Ranch is on the bottom left, while the John Show Ranch is at the right near Mulholland Drive. The Warner Movie Ranch was 2,800 acres. In 1959, the ranch was purchased and developed by a subsidiary of the Edison Company. An electric model community was built in the area, with 4,000 homes that were surrounded by an 18-hole golf course, 21-acre lake, tennis courts, equestrian clubs, and a shopping center that was later named "Calabasas Park."

HIDDEN HILLS, 1962. On September 19, 1961, Hidden Hills became the 73rd city in Los Angeles County. On August 21, 1962, the City Council of Hidden Hills was inaugurated. The first fiesta was held on October 20, 1962, celebrating the first anniversary of the city's incorporation on October 19, 1961. The movie star Monty Montana Jr. was the grand marshal of the parade that started on Long Valley and Oakfield Roads.

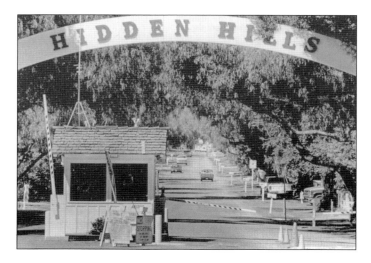

CANOGA PARK'S SHADOW RANCH, 1938. The Shadow Ranch is located at 22633 Vanowen Street. Between 1869 and 1872, Albert Workman purchased the ranch with partners Isaac Lankershim and Isaac Van Nuys. After Workman left around 1900, the ranch changed ownership until it was abandoned in 1932. In the following year, Colin and Florence Clements acquired the property and restored it, renaming it the Shadow Ranch. In 1959, the Shadow Ranch was developed into a city park after it was purchased by the City of Los Angeles in 1958.

CANOGA PARK HIGH SCHOOL, 1948. The Canoga Park High School was located on Canoga Avenue. In this photograph, it can be seen on the far left behind the trees. The high school was originally opened as Owensmouth High School in 1916, designed by the architect Henry Harwood Hewitt with a classic style and a Corinthian colonnade that faced south of Canoga Avenue. In 1931, its name changed from Owensmouth High School to Canoga Park High School.

FREDDIE & MAC SERVICE STATION, 1936. This service station was located at Canoga Avenue and Saticoy Street on the northern border of present-day Canoga Park. Such gas stations were little oases in the predominately agricultural San Fernando Valley. The Freddie & Mac station served Douglas gasoline.

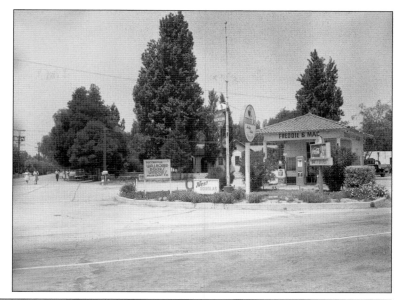

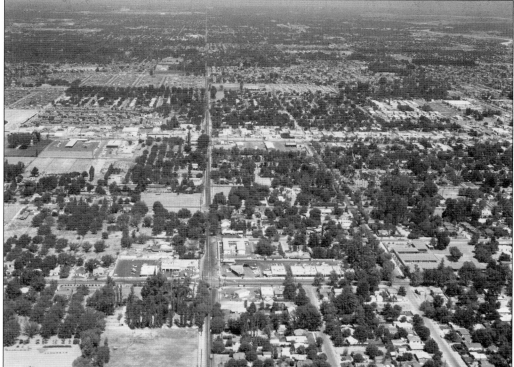

CANOGA PARK, 1956. This aerial image shows an easterly view of the intersection of Topanga Canyon Boulevard and Saticoy Street. By the mid-1950s, Canoga Park had already taken over most of the farmland in the vicinity. During the 1960s, the Topanga Plaza Shopping Center had the famous Ice Capades Chalet where public and professional skating was located. In 1987, much of the western portion of Canoga Park was renamed West Hills, and a portion of the eastern district was renamed Winnetka.

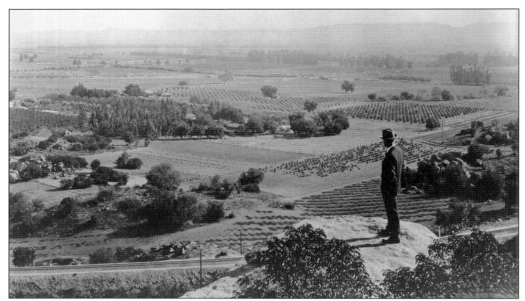

CHATSWORTH, 1920. This is a southeast view of the Iverson Ranch, Farralone Avenue, and the Southern Pacific Railway through the Santa Susana Pass Tunnel. Iverson Ranch was the most important ranch in Chatsworth and was located near the mouth of the Santa Susana Pass. Since 1912, there have been thousands of movies filmed at the Iverson Movie Ranch.

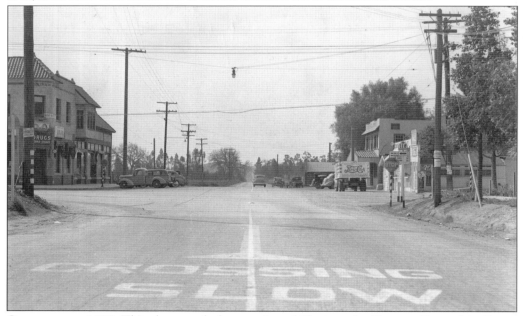

CHATSWORTH, 1939. This photograph shows a view of Chatsworth village on Devonshire Street and the intersection of Topanga Canyon Boulevard. The village was located at the junction leading to California State Route 118 and the town of San Fernando to the east. In 1928, the Crisler Building was built on the southeast corner of Devonshire Street. It would later house a bank, café, and drugstore. The village of Chatsworth was known in the 1920s as "Crisler's Top of the Valley Tract."

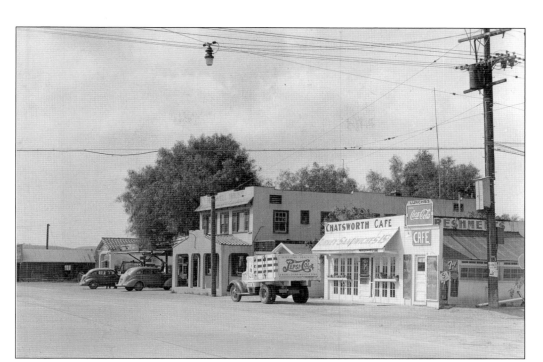

CHATSWORTH CAFÉ, 1939. This is the south side of Devonshire Street, where the Chatsworth Café, the Maxwell House Apartments, and the Chatsworth Service Station were located. Chatsworth at this time was known as the home of the Kadota fig ranches. It was also the home of the Iverson Ranch where movies were filmed since 1912.

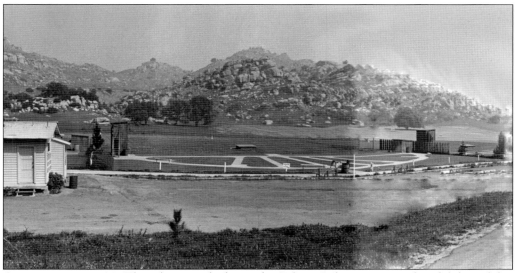

CHATSWORTH, 1964. This photograph shows the Palmer Lake recreational and fishing lake, which was located at the end of Devonshire Avenue. It was also the location of the Chatsworth Trap Shooting Club and the Aqua Sierra Country Club. In 1957, the Western Mid-Winter Trap Shooting Competition was held at the Chatsworth Trap Shooting Club. It was also the location of the Roy Rogers Handicap, an annual event.

CHATSWORTH CINEMA, 1966. This was the gala opening of the Cinema Chatsworth Theatre in July 1966. The theater opened with the premiere of the Universal Studios film *Arabesque*, which starred Gregory Peck and Sophia Loren. It was arranged to have Peck and Loren make a personal appearance at the new theater. The Chatsworth High School Marching Band and Majorettes were the entertainment in a street parade.

CHATSWORTH, 1962. This is a view of Devonshire Street at the intersection of Topanga Canyon Boulevard. It shows the old Crisler Building, which was built in 1928. The Chatsworth Pharmacy is still in the same building. The Chatsworth Hardware store next door was a landmark in Chatsworth for many years. The signage seen in the photograph gives directions to California State Routes 118 and 27.

Seven

THE CENTRAL VALLEY

Northridge was a part of the Ex-Mission Rancho lands acquired by Eulogio de Celis. The ranchland was sold to George K. Porter, who called it "The Valley of the Cumberland." Charles Maclay obtained the land after Porter and subdivided it. By the 1890s, the area was known as the Hawk Ranch. Francis Marion Wright and H.C. Hubbard took over the Hawk Ranch in 1887, and then sold it for subdivision in 1910. By 1920, the area was named Zelzah Acres. On July 1, 1929, the name changed to North Los Angeles. It changed again in 1938 to Northridge Village, and then to Northridge. On September 24, 1956, the Los Angeles State College of Applied Arts and Sciences opened. By 1958, the college's name changed to San Fernando Valley State College, and later, California State University, Northridge. With the coming of the 1970s, the Northridge Fashion Center opened; by 1976, the Northridge Hospital opened.

Reseda's original name was Marian. The original name was from Rancho Marian, which was founded in 1912. The area was named after Marian Otis Chandler, the daughter of *Los Angeles Times* publisher Harrison Gray Otis. By 1920, the name Reseda was chosen, from the North African flower *Reseda odorata*. Reseda's large ranches were finally subdivided after World War II; by 1949, much of the farmland disappeared because of the new housing developments.

On February 22, 1911, Isaac Van Nuys founded the City of Van Nuys. He was a partner in the Los Angeles Farm and Milling Association. Van Nuys built the first wooden-frame house in the Valley in 1872. By 1889, Harry Chandler, Harrison Gray Otis, and other investors bought out Van Nuys's land interests. Beginning in 1911, the city was sold as "the Town that Started Right." First on the development's list were the Bank of Van Nuys, the Pacific Electric Car Service, railroad station, post office, and real estate office. The Sepulveda Dam and recreation area was one of the largest recreation parklands. Formerly, Valley Glen was a part of Van Nuys until 1998. The Greater Valley Glen Council renamed the area Valley Glen.

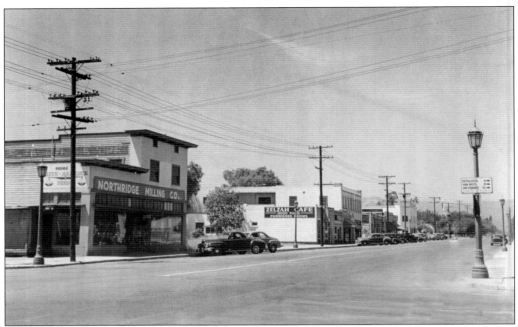

NORTHRIDGE, 1940. This is a view of old Northridge on north Reseda Boulevard and Eddy Street. The Northridge Milling Company was the home of Rite Balance Feed and Zelzah Café, which was the local hangout for many years on Reseda Boulevard.

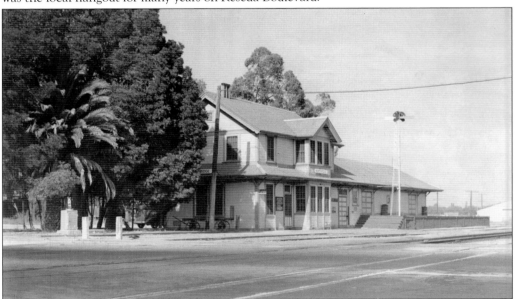

NORTHRIDGE RAILROAD STATION, 1939. In 1901, the Southern Pacific Railroad built another line in the Valley from Burbank through Zelzah and into the Chatsworth Tunnel. Due to grain farming in 1908, a Southern Pacific Railroad Station was built at the intersection of Reseda Boulevard and Parthenia Street. From 1908 to 1929, the station was called "Zelzah Station." From 1929 to 1938, it was named "North Los Angeles Station," and in 1938, the name was changed again to "Northridge SP Station." In 1961, the Northridge station was demolished.

DEVONSHIRE DOWNS, 1947. This photograph shows the grandstand and racetrack that was located on the 18000 block of Devonshire Boulevard. Between 1939 and 1947, there were 40 acres used to host fairs, rodeos, and the annual "Stampede" horse show. In 1947, the Quarter Horse and Harness Racing association took over and began horseracing. They called the track "Devonshire Downs." By 1948, the state of California purchased the site for the 51st District Agricultural Fair. It was later sold to California State University, Northridge in the 1960s, and it is now called the "CSUN North Campus."

NORTHRIDGE, 1960. This is a southern view of Zelzah Avenue and Devonshire Street. The Devonshire Downs racetrack is on the southwest corner of Zelzah and Devonshire. At this time, the Northridge area was still very rural, with farmland and citrus groves still dominating the landscape. On the right of the photograph is a large housing tract on Chatsworth Street, which was an area for the continuation of development in Northridge, and the place where it transformed into suburbia.

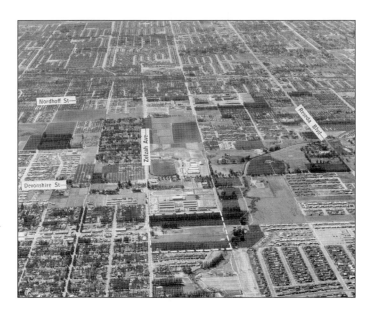

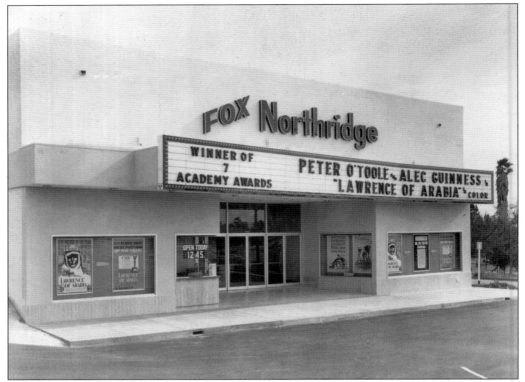

Fox Northridge Theatre, 1963. On September 11, 1963, the National General Corporation opened the new Fox Northridge Theatre at 10170 Reseda Boulevard. Northridge mayor Monte Montana attended the gala benefit premiere. The 896-seat theater had a modern style and a simple, practical design at that time.

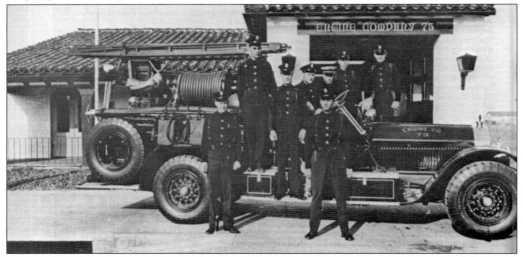

Reseda Fire Department, 1932. The crew of Engine Company 73 poses in front of their new fire station at the end of December 1932. The station was built in 1930, but there were no funds to man or equip it until two years later. The design of the station was Spanish Bungalow style, and it had a tiled roof. The station had only eight firemen to fight fires in their area.

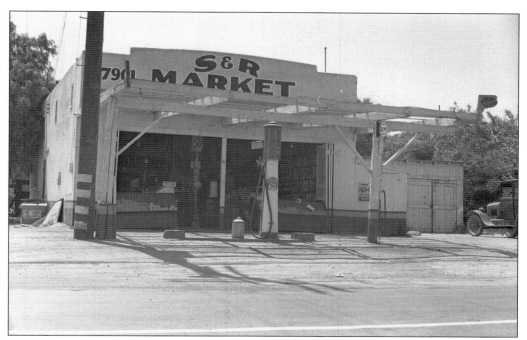

RESEDA, 1940. Here is the S&R Market at 7901 Reseda Boulevard at Strathern Street. This combination roadside market and gas station was the precursor for our modern gas stations that have a mini-market. This type of market/gas station was common in rural areas, serving residents who could not travel many miles for groceries.

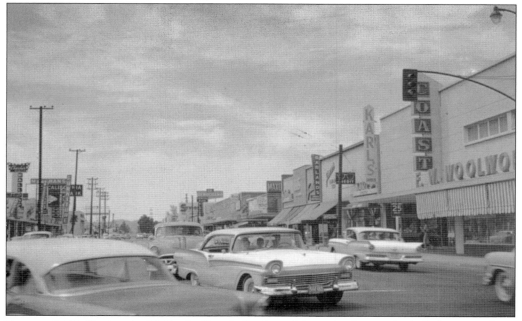

RESEDA, 1956. During the 1950s, the Reseda Boulevard shopping districts had all the major chain stores. Some of them are seen in this photograph: FW Woolworth, Karl's Shoes, Garlands, Dr. Beauchamp Dentists, McMahan Furniture, and the California Bank.

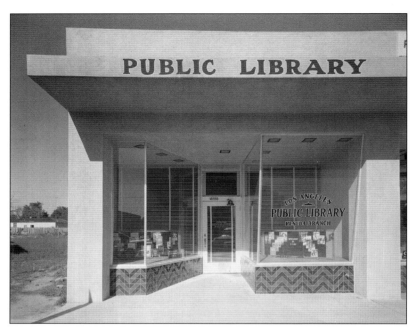

RESEDA, 1950. The Los Angeles Public Library Reseda Branch was located at 18555 Ventura Boulevard, which was east of Reseda Boulevard. Nina Wilson was the librarian at this branch; she was promoted to another branch in 1955. A new branch library opened on November 14, 1960, at 19036 Vanowen Street with Irene Carlson as the librarian.

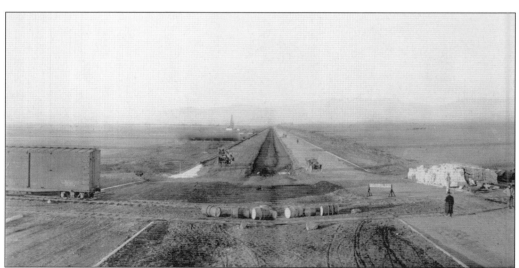

VAN NUYS, 1911. Shown here is the construction of old Sherman Way and the extension of the Pacific Electric Railway's line up the middle, which created the main thoroughfare through the Van Nuys Development. The junction between Sherman Way, whose name changed to Van Nuys Boulevard, and Cabrito Road was where the Southern Pacific railroad line crosses today's Van Nuys Boulevard.

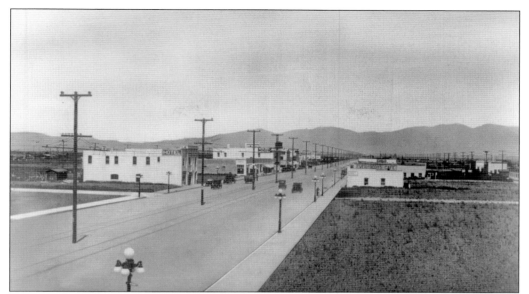

VAN NUYS, 1916. This is a northern view of Van Nuys Boulevard with its new sidewalks, streetlights, and Pacific Electric streetcar tracks. At the time, two of the businesses on the boulevard were Bevis Bros. Grocers and Everybody's Café.

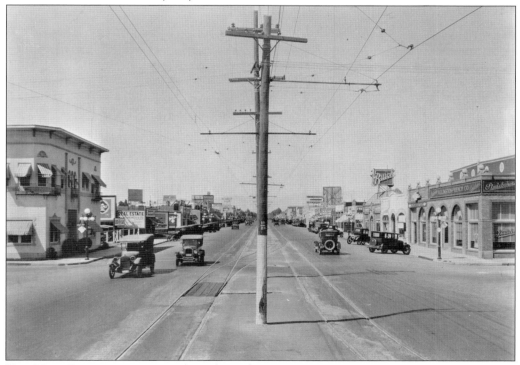

VAN NUYS BOULEVARD, 1927. Throughout the 1920s to the 1940s, the town grew with many diverse businesses. There were many automobile businesses that settled north on Van Nuys Boulevard and Calvert Streets. On the east side of the street were Allington-French Studebaker, Buick, and Nash and Ford agencies. Down the block was the Rivoli Movie Theatre.

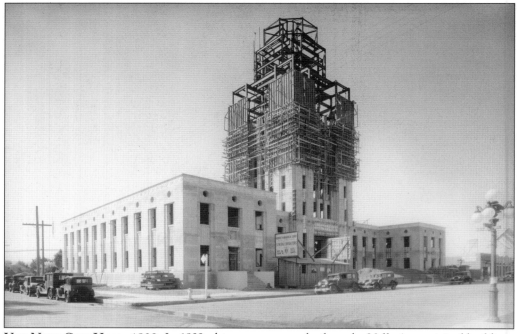

VAN NUYS CITY HALL, 1932. In 1932, this structure was built as the Valley's municipal building. The building had a steel frame with a central tower. The architect Peter K. Shaborum designed the building in the Art Deco–Moderne style, modeled as a miniature version of Los Angeles City Hall. It originally housed the Bureau of Engineering, a hospital, and police station, which were in one of the base wings along with the municipal court. In 1968, the city hall was designated a Los Angeles Historic-Cultural Monument. The restoration of the building and surrounding area began in May 2002.

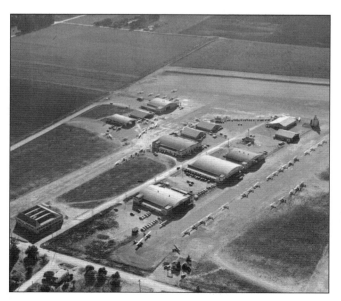

LOS ANGELES METROPOLITAN AIRPORT, 1936. The airport was built on 80 acres of walnut and peach groves in 1928, and was originally named the Los Angeles Metropolitan Airport. By 1933, the airport was bankrupt, and Drusilla Daily Warner acquired the property. By the 1940s, it passed to Warner's son Dean Daily. In 1942, the airport was seized by the army and became a training base. Later in 1949, the property became an airport for Los Angeles, and in 1957, it was renamed Van Nuys Airport. (Photograph courtesy of Nancy Ince Probert.)

VAN NUYS DRIVE-IN THEATRE, 1948. The Van Nuys Drive-In was one of several theaters owned by the Pacific Theatres Corporation in 1948. It opened on July 30, 1948. It was at Roscoe and Sepulveda Boulevards, and became a popular venue for many years. At the time this photograph was taken, the theater was showing the film *On an Island with You*, which starred Esther Williams and Peter Lawford.

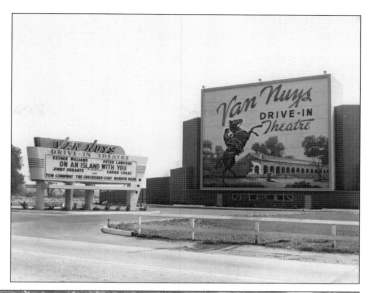

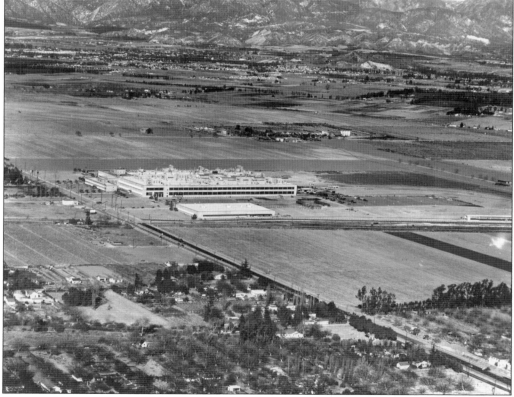

GENERAL MOTORS PLANT, 1951. This photograph shows an aerial view over Van Nuys Boulevard. The new General Motors plant was located at 8000 Van Nuys Boulevard and opened on December 1947. Chevrolet cars and trucks would be assembled there. In 1962, Corvairs were built at the plant. For more than 20 years, the plant was a major industry in Van Nuys. On August 27, 1992, the plant closed down.

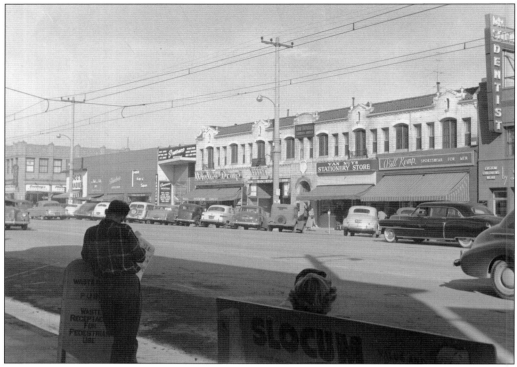

VAN NUYS BOULEVARD, 1952. This is the 6000 block of Van Nuys Boulevard south of Friar Street, which was the location for many postwar businesses. Businesses shown are, from left to right: Courdrey's Drugs, See's Candies (corner of Friar Street), Shirlee Dress Shop, Town Gift Shop, Standard Outfitters, Whelan Drugstore, Dr. R.E. Elliott, Sun Store, Law Office of Corman and Hansen, Van Nuys Stationery Store, Bill Kemp Sportswear, and Dr. Sitkin's dental office.

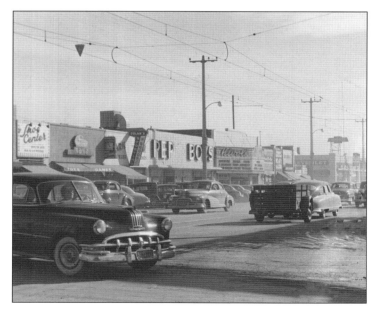

VAN NUYS BOULEVARD, 1952. This photograph shows the south corner of Friar Street on Van Nuys Boulevard. On the east side of the street was the Shoe Center, Toy Store, Stark Jewelers, Dolan's Sporting Goods, Pep Boys (once Thompson's Furniture Co. in 1945), and the Rivoli Movie Theatre. The Rivoli was the oldest theater in the Valley. It was opened in 1924 by Louis Greenberg and survived for over 30 years on Van Nuys Boulevard.

Busch Gardens Amusement Park, 1967. In 1966, August A. Busch Jr. created an amusement park called Busch Gardens in Van Nuys, adjacent to the Anheuser-Busch Brewery. The brewery opened in 1954. The amusement park was 20 acres and looked like a tropical paradise. It had 2,000 birds as well as a variety of animals, and visitors could take boat rides and have free beer. Later, the amusement park became a bird preserve, but it was closed down in 1986.

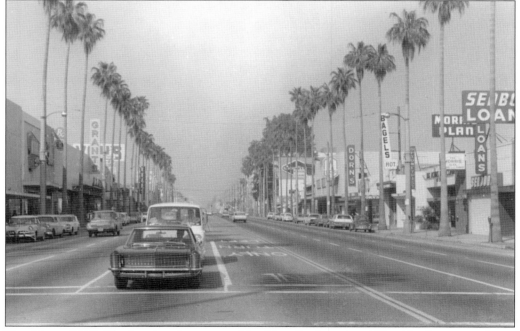

Van Nuys, 1965. The iconic palm trees on Van Nuys Boulevard and Kittridge Street are shown here. Some of the businesses on Van Nuys Boulevard were Seabord Loan Company, Dorn's, Goodyear Tire Store, Grant's, and Vons.

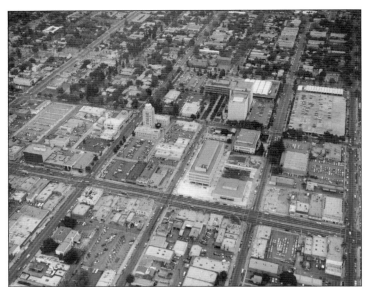

VAN NUYS, 1974. This is an aerial view of the city hall and former civic center. The photograph also shows the 6000 block of Van Nuys Boulevard, Sylmar Street, Sylvan Avenue, and Delano Street. The Van Nuys Public Library, community police station, federal building, and the Capri Theatre were all located in the downtown of Van Nuys.

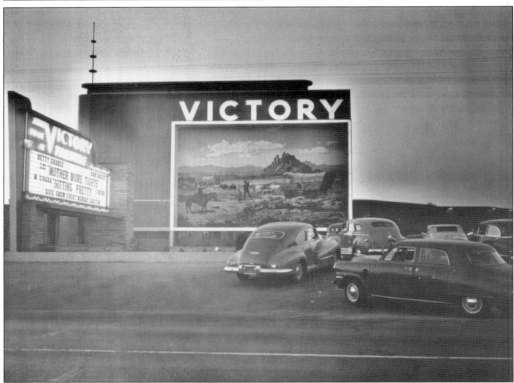

VICTORY DRIVE-IN THEATRE, 1947. The Victory Drive-In was part of Pacific Theatres and was one of several postwar theaters in the San Fernando Valley. It was once located at 13037 Victory Boulevard nearby Coldwater Canyon Boulevard, but the area is now Valley Glen. The theater opened in August 1947. The architect William Glenn Balch designed the building. In 1965, American International Pictures used the theater as the filming location for *Ski Party*, which starred Frankie Avalon and Dwayne Hickman.

Eight

MOTION PICTURE AND TELEVISION STUDIOS

In August 1909, the Chicago-based Selig Polyscope Company built the first permanent movie studio in Los Angeles. The studio was located in the Edendale district, which was north of downtown Los Angeles. The second company that came to Los Angeles was the Bison Film Company, which built a studio just down the block from the Selig studio. The Bison Film Company made western films and began shooting around the San Fernando Valley. The New York–based Biograph Company came to Los Angeles in 1910, and director D.W. Griffith built a studio in downtown Los Angeles. In 1911, the Nestor Film Company came to Los Angeles and built the first movie studio in Hollywood. In New York, the newly formed Universal Film Manufacturing Company decided to move most of its production to the west coast and settled in Hollywood in 1912. In the same year, they leased the Providencia Ranch, which was known as the Oak Crest Ranch. The Nestor Film Company became a part of the Universal Film Manufacturing Company. On July 10, 1913, the company created Universal City at the Providencia Ranch, which was the first motion picture studio in the Valley. In 1925, the company was incorporated as Universal Pictures. In 1926, the First National Pictures Corporation purchased a portion of Dr. David Burbank's farm and built a sound studio there. By 1928, the company became Warner Bros. Studios. Also in 1928, Al Christie and Mack Sennett opened a new studio in the newly created community of Studio City. By 1933, Mascot Pictures took over the Sennett Studios, which later merged with Republic Pictures in 1935. In Burbank, the Walt Disney Studios built a new studio in 1940; its location is now on Buena Vista Street and Alameda Avenue. Nearby, the National Broadcasting Corporation (NBC) purchased land for its television studio facility in 1952.

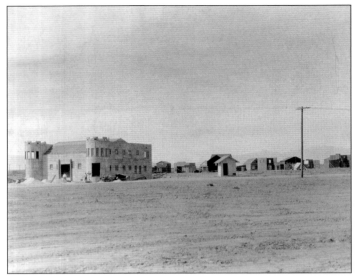

THOMAS C. REGAN STUDIO, 1925. The Thomas C. Regan Studio was built in 1925. The original address was 8405 Reedley Street in Van Nuys, but the street numbers were changed in 1930. The current address number is 13251 Reedley in Panorama City. Although the company never completed or released a film, the administration building of its studio still stands. It serves as the Panorma City's American Legion post. (Photograph courtesy of Robert S. Birchard.)

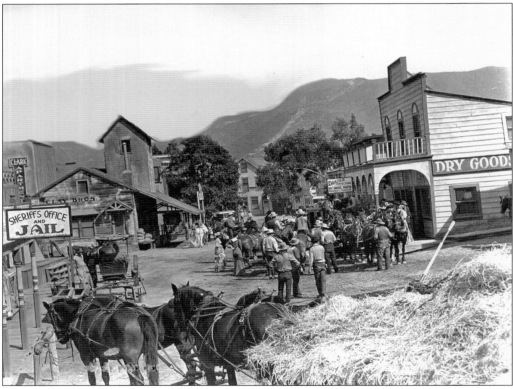

COLUMBIA RANCH, 1940. The Columbia Ranch was located at 3701 Oak Street near Hollywood Way in Burbank. Columbia Pictures purchased 40 acres of the ranchland in 1934. By 1935, there was a western town and other background settings at the ranch. In 1936, the biggest set built at the ranch was for the film *Lost Horizon*. By 1949, Columbia purchased another 40 acres adjacent to the ranch for expansion. Here, the western town is being used for the 1946 film *Renegades*, directed by Vincent Sherman.

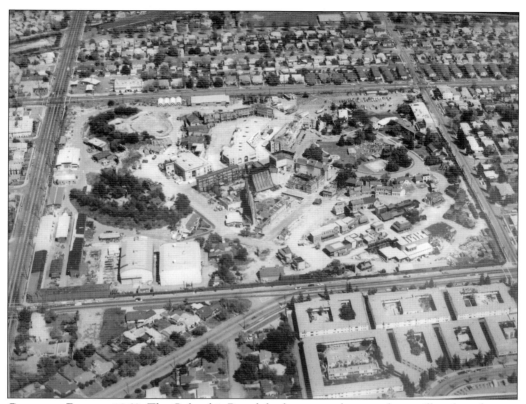

COLUMBIA RANCH, 1963. The Columbia Ranch had two sound stages, shop-mill and production support facilities, a New York street, European street, western town, train station, small town streets, residential street, swimming pool, park, brownstone street, and an artificial lake. In 1960, the ranch had five sound stages. On January 30, 1970, a fire destroyed one of the stages, a part of the western street, the train station, European street, and the "Blondie" house.

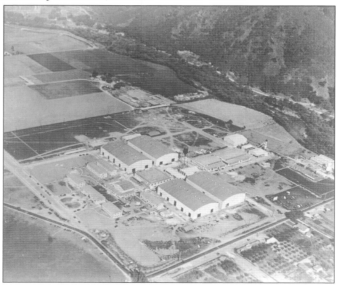

FIRST NATIONAL STUDIOS, 1926. This was the newest sound studio built in the Valley during the 1920s. The new First National studio was located on Barham Boulevard and West Olive Avenue. It was built with sound stages, offices, dressing rooms, and production buildings. The buildings were designed in the Spanish Colonial style of architecture. The 48-acre site was built on Dr. David Burbank's property. This studio was the first sound studio in the San Fernando Valley.

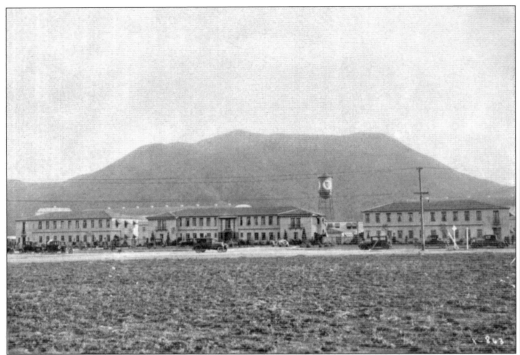

FIRST NATIONAL STUDIOS, 1927. This is the area that is now Riverside Drive and the administration building on Warner Boulevard. In 1917, First National Studios was founded by a group of exhibitors. Warner Bros. Studios purchased the company in September 1928. The two companies continued to retain separate identities until the mid-1930s. From 1941 to 1958, most Warner Bros. films bore the combined trademark "A Warner Bros.–First National Picture."

FIRST NATIONAL STUDIOS, 1930. This photograph shows the First National–Warner Bros. studio lot and several sound stages with the Theatre Set stage on the right. Here, many men stood in as soldier extras during the film *Back Pay*, which starred Corinne Griffith and was released in June 1930.

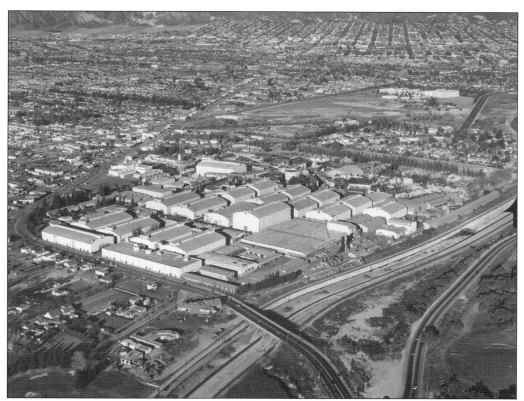

WARNER BROS. STUDIOS, 1949. This photograph shows a northeastern view over the Los Angeles River and Barham Boulevard. In 1912, brothers Harry, Albert, Sam, and Jack Warner originally founded Warner Bros. Pictures. For the next 11 years, the company had various names until 1923, when it became Warner Bros. Pictures. Their first studio in Hollywood was located at Sunset Boulevard and Van Ness Avenue, but all production eventually vacated the Hollywood studio lot by the late 1950s.

WARNER BROS. AND FIRST NATIONAL STUDIOS, 1933. This is the Warner Bros. studio gate on Barham Boulevard and the security guard station that was attached to the Property Department Building. During the 1930s, Warner Bros. Pictures led the way in the production of films that were inspired by the Great Depression. The company produced a cycle of gangster films, many of them starring James Cagney, Edward G. Robinson, and Humphrey Bogart.

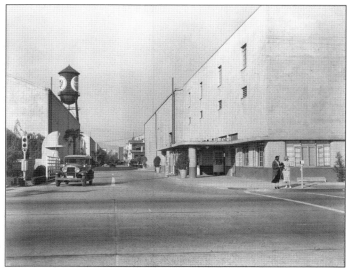

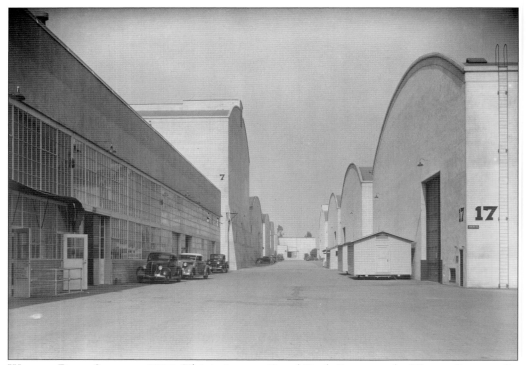

WARNER BROS. STUDIOS, 1936. This is Avenue D and Sixth Street on the Warner Bros. studio lot. On the left is the set-and-prop building department and Stage 7, which was known as the Marion Davies Stage because of the film *Cain and Mabel* starring Davies and Clark Gable. During the 1930s and 1940s, many biography films were produced, such as *Louis Pasteur, Zola, Juarez,* and *Dispatch from Reuters*, with stars such as Paul Muni, Errol Flynn, Bette Davis, and Olivia de Havilland.

WARNER BROS. STUDIOS, 1959. This photograph shows the administration building that faced Warner Boulevard, which was formerly built by First National Pictures. Warner Bros. Pictures continued its success in the 1940s with stars such as Humphrey Bogart, Peter Lorre, and others. In the 1950s, Warner Bros. began to make television series that proved to be extremely popular. Some of these included *Maverick, 77 Sunset Strip, Hawaiian Eye,* and *Lawman.*

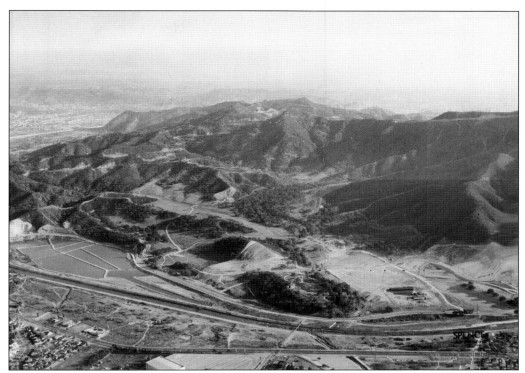

PROVIDENCIA RANCH AND LASKY RANCH, 1951. This is a southeastern view over the Los Angeles River, Riverside Drive, and Buena Vista Street. In 1911, the Nestor Film Company was the first to begin filmmaking at the Providencia Ranch. In 1912, Universal Film Manufacturing Company leased the ranch, and by 1913, they established Universal City there. By 1914, the company moved to Lankershim Boulevard, and the Providencia Ranch became a location backlot used by the Lasky Company. The ranch was known throughout the years as the "Providencia and the Lasky Ranch" until it became Forest Lawn Memorial Park.

MACK SENNETT STUDIOS STUDIO CITY, 1931. This is the northeast intersection of Ventura Boulevard and Radford Drive. The Mack Sennett Studios was adjacent to the Los Angeles River. Both Studio City and the Mack Sennett Studios were opened in 1928. The studio was the second sound studio built in the San Fernando Valley.

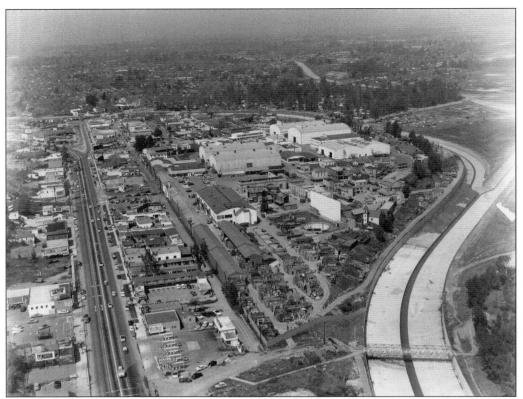

REPUBLIC STUDIOS, 1955. This aerial photograph shows Ventura Boulevard on the left and the Los Angeles River on the right. Republic Pictures studio took over the former Mack Sennett and Mascot Studios in 1935. Republic Pictures was a subsidiary of Consolidated Film Industries, which was a film laboratory company established in 1915. The founder and president of Republic Pictures, Herbert J. Yates, took over the studio's premises and began producing B-listed movies, westerns, and serials.

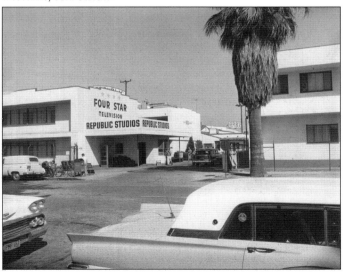

REPUBLIC STUDIOS, 1960. This image shows the main entrance to the Republic Pictures and Four Star Television studios at 4030 Radford Drive. Some of the celebrities from Republic Pictures, between 1935 and 1949, were Johnny Mack Brown, John Wayne, Gene Autry, Roy Rogers, and Ray "Crash" Corrigan. By 1960, the studio had been leasing space to independent film and television companies such as Four Star Television and Mark VII Limited Productions.

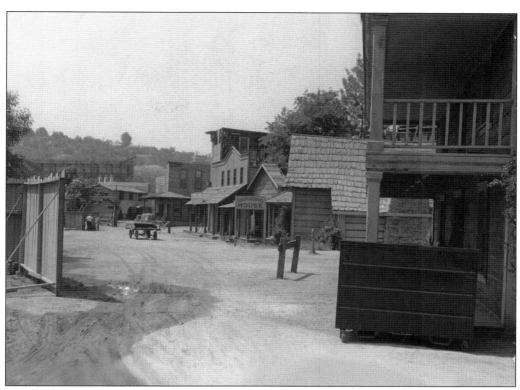

REPUBLIC STUDIOS AND CBS STUDIO CENTER, 1965. This is Brazo Street of a western town movie set on a backlot. At this time, the western town movie set was also known as the CBS Western Town. During the 1950s, Republic Pictures slowly abandoned most of its film production for television shows. The CBS Western Town was used for famous television shows such as *Zane Grey Theatre*, *The Rifleman*, *Wanted Dead or Alive*, *Gunsmoke*, *Rawhide*, *The Big Valley*, and *Wild Wild West*.

CBS STUDIO CENTER, 1978. The gate of the CBS Studio Center was located at 4024 Radford Avenue, where the administration building was as well. On May 1, 1963, the CBS Television Network took over the Republic Pictures studio with a five-year lease and renamed the facility the CBS Studio Center, or Studio Center. CBS finalized the purchase of the former Republic Pictures studio in 1967.

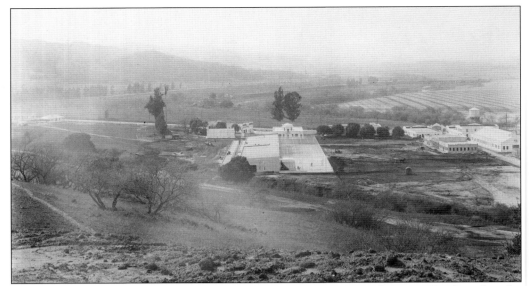

UNIVERSAL STUDIOS, 1914. This photograph shows a western view of Ventura Boulevard in the foothills, Lankershim Boulevard, and the first buildings of Universal Studios. The new studio lot included administration buildings, the main stage, the shop area, the laboratory, and electrical department. Universal Pictures was formed in 1912 and almost immediately began production in Hollywood at the Providencia Ranch. In 1913, Universal Pictures established its Universal City at the ranch, but moved it to the Lankershim site in 1914.

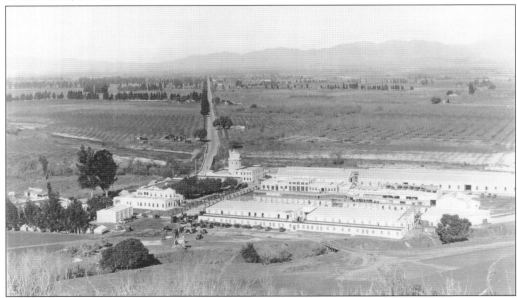

UNIVERSAL STUDIOS, 1915. This image shows a northwest view of Universal City, North Hollywood, Lankershim Boulevard, and Universal Studios with its whitewashed buildings. The main buildings consisted of two main stages, Universal Studio Tours, and the production support facilities that were on the north side of the lot. At this time, the studio had formerly opened on Lankershim Boulevard. Stars who were with Universal included Jack Warren Kerrigan, Harry Carey, Lon Chaney, Wallace Reid, Florence Lawrence, and Hoot Gibson.

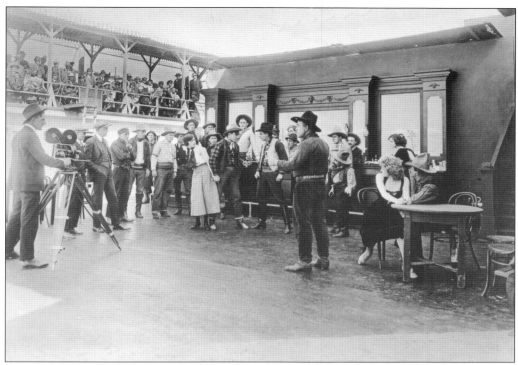

UNIVERSAL STUDIOS, 1916. On the main stage, the Harry Carey Western unit performs a scene showing the early Universal Studios Tour behind. Tourists could see a film being made from the tour gallery. Harry Carey is in the center of the photograph, holding the girl's hand. Most scenes during the silent era of filmmaking were done on an open stage.

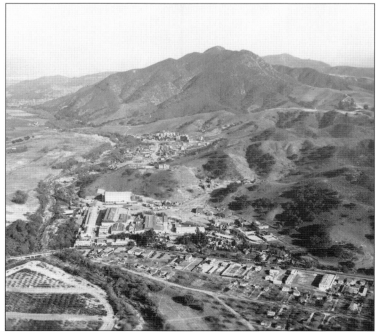

UNIVERSAL STUDIOS, 1925. This photograph shows Universal Pictures's vast ranch property. In the distance, nestled in the foothills, are the arches of the Notre Dame cathedral set that was used for the film *The Hunchback of Notre Dame*. The *Phantom of the Opera* stage is in the center. The Universal Pictures property spanned from the foothills of Mt. Hollywood, to the Los Angeles River, to Barham Boulevard, and to Dark Canyon.

UNIVERSAL STUDIOS, 1949. Located on Lankershim Boulevard, the administration building, publicity offices, laboratory, and commissary were the original structures from 1915. The Spanish Colonial buildings were demolished and replaced with the new MCA and Universal City Plaza by 1964. All that survived was the original Tiffany stained-glass round window that depicted the Universal logo, which is seen over the front door to the administration building in the photograph. Today, it has been preserved by the Production Department.

UNIVERSAL STUDIOS, 1985. This image shows an aerial view of MCA and Universal Studios, Lankershim Boulevard, and the Los Angeles River. The photograph also shows the density of buildings that gradually were added over the 70 years of Universal Pictures's growth. On the left is Universal Studios, in the center are the MCA and Universal City Plaza office buildings, and to the right is the Texaco Tower. Behind on the hill is the Universal Tour and City Walk Amusement Park.

WALT DISNEY STUDIOS, 1941. Walt Disney strolls around his studio at lunchtime while relaxing and talking to some of his staff. This was a regular routine for Disney, as he wanted to keep in touch with what was going on in the studio. According to a caption on this photograph, "In the background are some of the staff who helped produce *The Reluctant Dragon*, the latest Disney Feature Film." A touring film was made at this time, showing all the departments of the Disney studio.

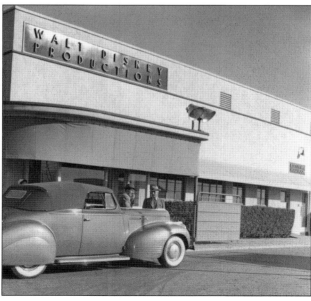

WALT DISNEY STUDIOS MAIN GATE, 1941. This is a rare photograph of Walt Disney talking to an associate at the Buena Vista Gate while leaning on his 1940 Packard. Disney had a hands-on approach to running his studio, and he knew almost everyone by name. It was at this time, just before World War II, that the studio was making almost exclusively animated films. After the war, the Disney Company began to produce live-action films that expanded the company's revenue.

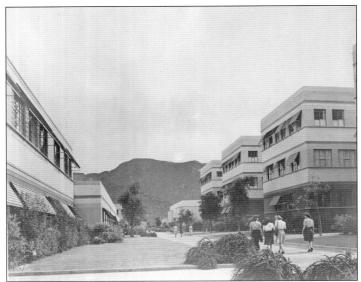

WALT DISNEY STUDIOS, 1945. This photograph shows a group of girls on the Disney lot. On the right is the animation building, which was where most of the creative artwork was done. Walt Disney Studios was originally designed around the animation process of filmmaking. The large animation building was in the center of the campus; adjacent to it was the story department, music department, and the ink-and-paint departments.

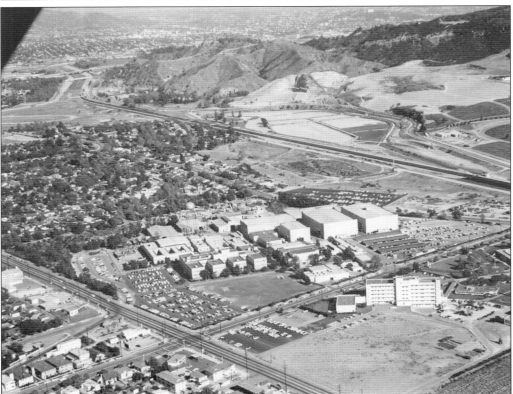

WALT DISNEY STUDIOS, 1958. This is an aerial view of Walt Disney Studios and the southeast intersection of Alameda Avenue and Buena Vista Street. At the bottom right is the Providence St. Joseph Medical Center. At this time, Disney Studios had expanded, with new sound stages and office buildings. The studio also had a small backlot where many of the Disney television shows were shot.

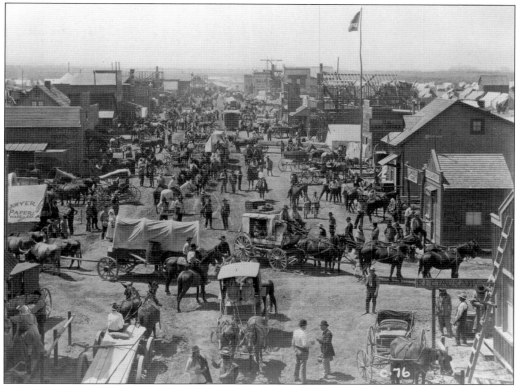

RKO Ranch Encino, 1931. This is a still photograph from the epic film *Cimarron* about the 1889 and 1893 land rush in the Oklahoma territory. RKO Pictures purchased a plot of ranchland near the Southern Pacific Railroad line in Encino, California for filming. *Cimarron* was the first film shot at this new ranch. The buildings in this photograph were later made more permanent, and this marked the beginning of construction of many permanent sets on the lot.

RKO Ranch Encino, 1953. The RKO Ranch was located between Burbank Boulevard, Louise Avenue, Oxnard Street, and the current Balboa Sports Center. For over 20 years, the RKO Ranch was a landmark in the Valley until it was torn down to make way for a housing development. At this time, the ranch had about 10 major sets on it.

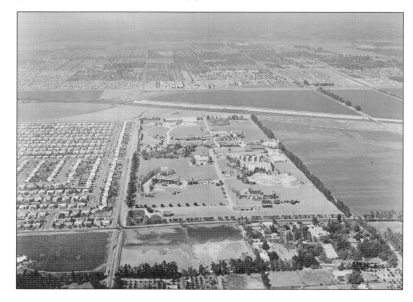

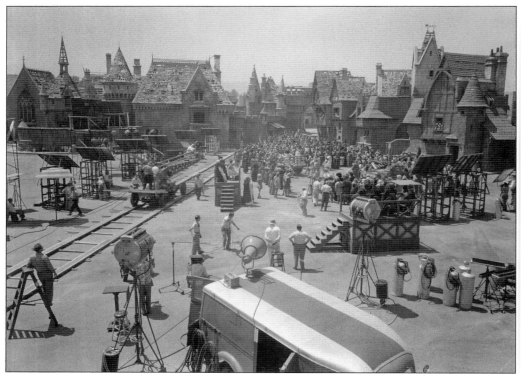

RKO Ranch Encino, 1948. The Jesse L. Lasky Production of *The Miracle of the Bells* used the former sets from the film *The Hunchback of Notre Dame*. The set is used as the medieval Paris background for a scene in *The Miracle of the Bells* that depicted the filming of a *Joan of Arc* sequence. At that time, the sets already were deteriorating from age and neglect.

RKO Ranch Encino, 1946. James Stewart prepares for a scene in *It's a Wonderful Life*. The scene is in the fictional Bedford Falls town, which was actually the small town set at the RKO Ranch. The Bedford Falls town was a modified version of the western town set from the original film *Cimarron*. RKO crews reconstructed the old set, which covered four acres of the ranch and included 75 stores and buildings. The Encino backlot was shut down in 1953. Howard Hughes, the owner of RKO pictures, sold it off. By 1954, the studio lot's sets and buildings were demolished for a housing development.

Nine

FILMING LOCATIONS AND HOMES OF THE STARS

For over 100 years, the San Fernando Valley and its historic monuments were used as the backgrounds for films. The San Fernando, San Gabriel Missions, and the former ranches of the 19th century, along with the adobe houses, became film locations. In 1911, the Nestor Film Company, which established the first studio in Hollywood, used the Providencia Ranch as its principal location for filming westerns. From then on, the Valley became Hollywood's backlot. In 1915, film director Cecil B. DeMille purchased a ranch alongside the Tujunga River and called it Paradise. By 1929, because more studios were established in the Valley, many prominent stars moved to the Los Angeles area.

During the 1930s and 1940s, the Valley became the location of ranch homes of celebrities close to Hollywood. Many of them were horse lovers who maintained horse ranches in the Valley. For years, Northridge became the "horse capital" of California. In the 1930s, actor Francis Lederer purchased a ranch in Canoga Park. In 1935, singer and actor Al Jolson purchased a five-acre ranch in Encino. In 1935, an article in the *Los Angeles Times* had a headline that read, "Many Leaders of Filmdom Own Rural Realty." In the 1930s, Gene Autry, Bob Hope, Roy Rogers, and others were joining the ranks of those living in the Valley. In the 1940s and 1950s, stars such as Dinah Shore, Liberace, and John Wayne joined the Hollywood colony there. In 1950, Wayne and his second wife bought a two-story-colonial home on five acres in Encino. At one time, the following celebrities lived in the San Fernando Valley: Walter Brennan, Lou Costello, Yvonne De Carlo, Clark Gable, Susan Hayward, Lucille Ball, and Desi Arnaz, among many others..

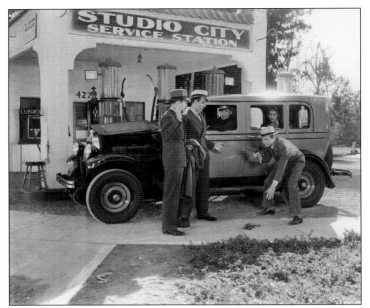

STUDIO CITY LOCATION, 1936. Paramount Pictures's production of *F Man* was filmed in the San Fernando Valley. One scene is at a gas station, which was located at 4272 Laurel Canyon Boulevard. In the scene, Jack Haley Sr. is disarming some "bad guys" while Adrienne Marden waits in a taxi. During the 1930s, most gas stations were small mom-and-pop operations that had only four pumps and a small market inside. There were no supermarkets in the Valley until the late 1940s.

STUDIO CITY LOCATION, 1961. This image shows Mickey Rooney and Buddy Hackett in the Columbia Pictures comedy *Everything's Ducky*. They are on location at the Sportsmen's Lodge in Studio City. In the film, Rooney and Hackett take "Scuttlebutt the Talking Duck" for a drink at the Sportsmen's Lodge ponds. Originally, the Sportsmen's Lodge had fishing ponds that surrounded the restaurant, and customers could actually catch a fish and have it prepared in the Lodge's kitchen.

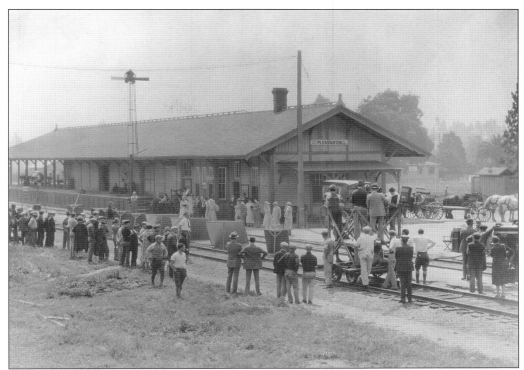

NORTH HOLLYWOOD LOCATION, 1927. The Lankershim Train Depot was North Hollywood's oldest structure, built in 1895 near Lankershim and Chandler Boulevards. The Lankershim Depot posed as the rural Pleasanton train station in the Cecil B. DeMille and Pathe production *The Country Doctor*. The film starred Rudolph Schildkraut. Today, the station is under consideration as a historical landmark, and is a potential location for the North Hollywood Museum.

VALLEY GLEN PREMIERE EVENT, 1957. The Victory Drive-In Theatre was the site of a premiere opening of Paramount Pictures's *The Devil's Hairpin*, which starred Cornel Wilde and Jean Wallace.

Los Angeles Metropolitan Airport Location, 1942. In the film *Casablanca*, a false gate was built for the airport scene when Maj. Strasser arrives in Casablanca. This scene was shot at the Los Angeles Metropolitan Airport, which was later renamed the Van Nuys Airport. The "Casablanca Hangar" at the Van Nuys Airport was built in 1928 and demolished in 2007.

Los Angeles Metropolitan Airport Location, 1939. In the film *Flying Deuces*, Laurel and Hardy escape from a death sentence in the Foreign Legion on a stolen airplane at an airport in North Africa. The Los Angeles Metropolitan Airport was the scene for the African airport.

WOODLAND HILLS LOCATION, 1956. A crime drama unfolds on Topanga Canyon Boulevard in the film *The Man Is Armed*, which starred Dane Clark. Police set up a roadblock in order to catch robbers just north of Del Valle Street. The crime drama involves a man who unknowingly helps a gang pull off a big heist.

WOODLAND HILLS LOCATION, 1961. In the film *Bachelor in Paradise*, Bob Hope flirts with both suburban housewives Lana Turner and Paula Prentiss. The movie's ranch homes were nearly new when the film was made, and they can still be found near the intersection of Valmar Road and Mulholland Drive in Woodland Hills.

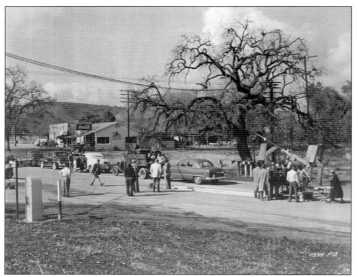

OLD TOWN CALABASAS LOCATION, 1949. The filming of the Universal Pictures production *Take One False Step*, which starred William Powell and Shelley Winters, is seen here at a rural area on the corner of Calabasas Road and El Canon Avenue. The filming location was across the street from the Leonis Adobe and the Sagebrush Cantina. Today, the Motion Picture and Television Fund (MPTF) Country Home and its hospital are near this site.

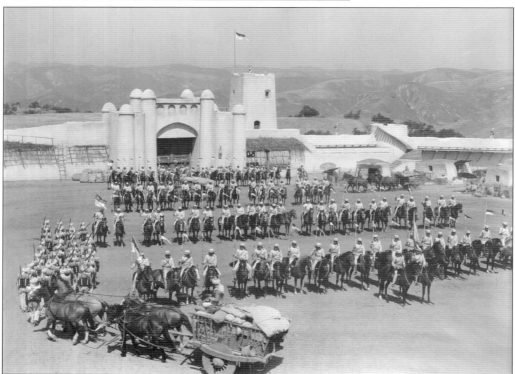

UPPER LAS VIRGENES CANYON LOCATION, 1936. The area just north of Calabasas and off Las Virgenes Road provided an expansive setting for the film *The Charge of the Light Brigade*. The location was at the Lasky Mesa Ranch. Later known as the Ahmanson Ranch, the property was sold to the Santa Monica Mountains Conservancy in 2003. The ranch is still used for filming large-scale set pieces such as the bridge ambush in the film *Mission: Impossible III*. Lasky Mesa also was used as a background for the film *They Died With Their Boots On* and as a cotton field for the film *Gone With The Wind*.

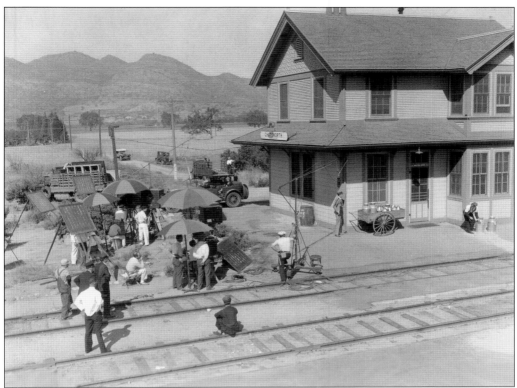

CHATSWORTH LOCATION, 1929. Paramount Pictures used the Southern Pacific Chatsworth Railroad Depot for the film *Half Way To Heaven*, which starred Charles "Buddy" Rogers and Jean Arthur. The Chatsworth Park Railway Station was once located at Marilla Avenue near Topanga Boulevard. The Southern Pacific Railroad built the railway station for Chatsworth Park in 1893. In 1917, the original depot burned down and a second, larger station was built between Devonshire Street and Lassen Street.

NORTHRIDGE LOCATION, 1947. This image shows producer Jerry Fairbanks bringing his production of *Doctor Jim* to the Southern Pacific Northridge Railroad Depot. The film, which starred Stuart Erwin and Barbara Woodell, is about a small-town doctor who looks back at his 30-year career. The station is located at Eddy Street, just west of Reseda Boulevard. It was a major railroad stop through the central San Fernando Valley.

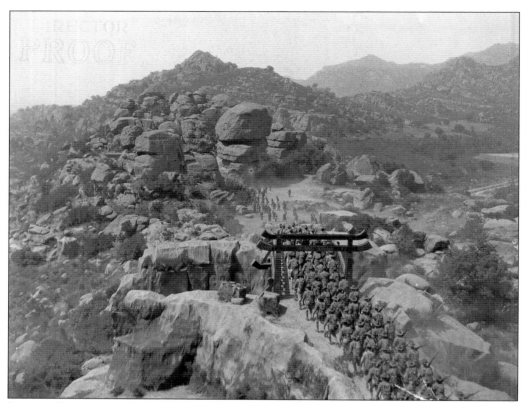

IVERSON RANCH AND CHATSWORTH, 1926. The Iverson Ranch was one of the most important independent movie ranches in California. It was established by the Iverson family in the northwest Valley, and the earliest films made on the ranch date back to 1912. This image shows the "Garden of the Gods" section of the ranch, which is a place with incredible rock formations, during filming of a scene from *Tell It to the Marines*, which starred Lon Chaney and was set in China.

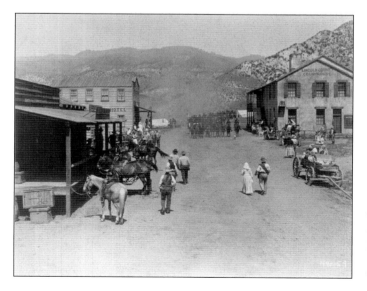

PORTER RANCH LOCATION, 1930. The foothills of the present-day Porter Ranch were the film location for *Billy the Kid*, which was directed by King Vidor and starred Wallace Beery and Johnny Mack Brown. The town that was built for the film represented Lincoln, New Mexico. In this photograph, the US Cavalry enters the town.

SAN FERNANDO MISSION LOCATION, 1921. This photograph shows silent movie star Rudolph Valentino in *Four Horsemen of the Apocalypse*, which was directed by Rex Ingram. The scene is at the San Fernando Mission. The mission was founded in 1797. Since 1909, the missions of San Gabriel and San Fernando have been popular filming locations.

SUN VALLEY LOCATION, 1920. Douglas Fairbanks Sr. produced and starred in the film *The Mark of Zorro*. The Fairbanks Company built a hacienda set at the intersection of Stonehurst Avenue and Sunland Boulevard. It was located in the town of Roscoe, which was later renamed Sun Valley. The elaborate set was a replica of old Californian rancho settlements of the 1840s, and included a church, hacienda, mansion, and stable area.

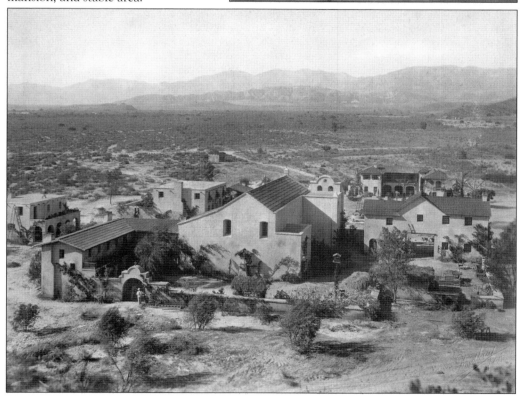

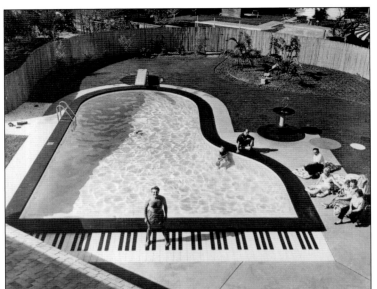

LIBERACE, SHERMAN OAKS, 1957. In 1953, Liberace designed and built a house with a piano theme in Sherman Oaks. The interior had lavish furnishings and antiques, which included an important antique piano. Liberace also designed a piano-shaped swimming pool with a keyboard tile decoration. It was a modest-sized house that was big enough for his mother.

AL JOLSON AND RUBY KEELER, ENCINO, 1937. Encino became a popular place for celebrities' homes over the years. One of the more famous of these was the Al Jolson and Ruby Keeler ranch-style estate, which was located at 4875 Louise. It was a half block south of Ventura Boulevard and had two stories, servants' quarters, a pool area, and tennis courts. Jolson lived there until his divorce from Keeler.

CLARK GABLE, ENCINO, 1938. This estate was formerly the home of director Raoul Walsh, and was called "Encino Acres" since 1933. In 1938, Walsh sold the estate to Clark Gable. Gable and his wife Carole Lombard lived there, and after his marriage, Gable renamed the property the "House of Two Gables." The estate, located at 4525 North Petit Avenue, had a large two-story ranch house, caretaker house, stables, swimming pool, and servants' wing. Gable lived at the estate until his death in 1960.

ROY ROGERS, CHATSWORTH, 1953. In 1952, Roy Rogers and Dale Evans moved into their new home, which was located at 9839 Andora Avenue. The Rogers family became well-known Chatsworth celebrities. Rogers always attended the horse shows or skeet shooting matches at the nearby shooting club. Chatsworth was a horse town. Rogers and Evans kept their horses near them and could be seen riding in the neighborhood.

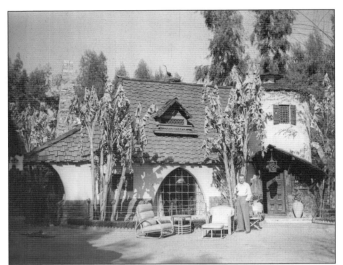

BELA LUGOSI, NORTH HOLLYWOOD, 1942. This house at 10401 Whipple Street in North Hollywood was Bela Lugosi's favorite home. The European fantasy-style house was called a "Hollywood star's haven." His son Bela George Lugosi, who was a young boy at the time, loved the Whipple house. As Bela George described it, "There was a huge enclosed front yard with tall trees and shrubs with paths, ponds and a garden."

STAN LAUREL, CANOGA PARK, 1944. After living in Beverly Hills for many years, Stan Laurel moved to Canoga Park where he could garden and raise ducks. Stan built a high brick wall and gate in front of his house, and put up a sign that read "Fort Laurel." Oliver Hardy lived nearby in Van Nuys. This photograph had a caption that read, "Laurel and Hardy invite Elena Verdugo, the girl next door, to come over to Fort Laurel, Stan's ranch in the Valley, to help them with their Victory Garden."

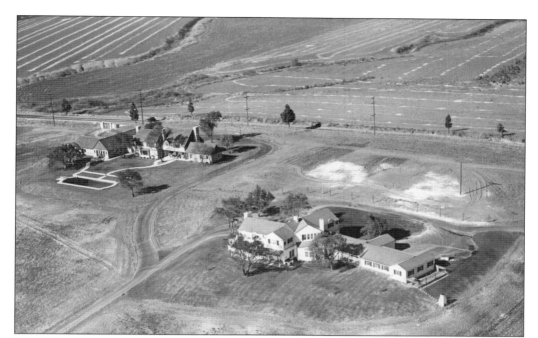

BARBARA STANWYCK, NORTHRIDGE, 1937. In 1936, Barbara Stanwyck owned a Brentwood Ranch in Mandeville Canyon. By 1937, Stanwyck commissioned the famed architect Paul Williams to design a new ranch-style home. It was located on 18650 Devonshsire Street and had 11 acres in Northridge, which was zoned for equestrian pursuits. Stanwyck and friend Zeppo Marx purchased adjacent properties and called their new properties "Marwyck."

JACK OAKIE, NORTHRIDGE, 1963. In 1950, the actor Jack Oakie and his wife, Victoria, purchased the Marwyck property and renamed it "Oakridge." The couple lived there until Jack passed away in January 1978. Victoria later donated the house and grounds to the University of Southern California. It was later sold to developers. In 2010, the City of Los Angeles acquired Oakridge to use as a park. The estate is an example of a historical equestrian property. Today, the house and grounds are a Los Angeles Historic-Cultural Monument, labeled as n o. 484.

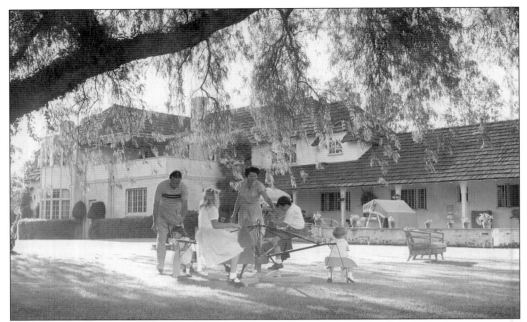

BOB HOPE, TOLUCA LAKE, 1940. Bob Hope and his wife, Dolores, purchased this home in 1940. They moved in with their four adopted children, Linda, Anthony, Kelly, and Nora. The new home was located at 10346 Moorpark Street in Toluca Lake. Eventually, the couple purchased the surrounding properties and created a nine-acre estate.

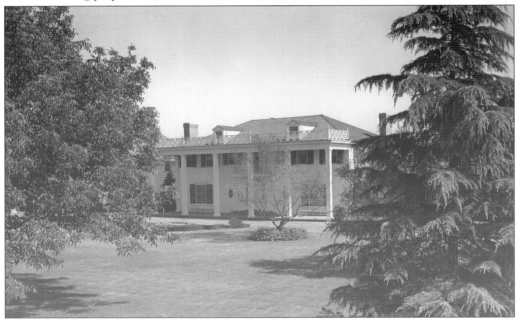

BING CROSBY, TOLUCA LAKE, 1938. This photograph shows one of Bing Crosby's houses in Toluca Lake, at 10500 Camarillo Street. Crosby wanted to live in the Toluca Lake district of North Hollywood because of the Lakeside Country Club and Golf Course. He was also close to Bob Hope, who lived nearby.

GENE AUTRY, NORTH HOLLYWOOD, 1940. This image shows one of Gene Autry's homes in the San Fernando Valley. In 1949, he built a new house at 3171 Brookdale Road in Studio City, and lived there until his death in 1998.

FRANK SINATRA, NORTH HOLLYWOOD, 1944. This photograph shows the first home Frank Sinatra bought in North Hollywood after his success in New York. He lived at this house while he began a filming career at RKO Pictures and then at MGM Studios.

DISCOVER THOUSANDS OF LOCAL HISTORY BOOKS
FEATURING MILLIONS OF VINTAGE IMAGES

Arcadia Publishing, the leading local history publisher in the United States, is committed to making history accessible and meaningful through publishing books that celebrate and preserve the heritage of America's people and places.

Find more books like this at
www.arcadiapublishing.com

Search for your hometown history, your old stomping grounds, and even your favorite sports team.